D1413479

COLOR
STRUCTURE
AND
DESIGN

RICHARD G. ELLINGER

VNR VAN NOSTRAND REINHOLD COMPANY

NEW YORK CINCINNATI TORONTO LONDON MELBOURNE

Acknowledgments

I am indebted first of all to my students who have been willing to explore new avenues to creative color. My thanks to Don Beehler, Gene Carara, and E. L. Isaacson for permission to show some of their class projects, and to the other students whose work, though not included in the final selection, was made available to me.

For permission to reproduce their paintings I am indebted to Watson Bidwell of Colorado State College, Jean Charlot of the University of Hawaii, and Vance Kirkland of the University of Denver; and to Miss Joy S. Weber for permission to show *Mexican Jug*, one of her father's paintings. I appreciate the courtesy of Mr. and Mrs. Lester B. Garner in allowing me to reproduce *Didi Playing the Guitar*.

Thomas Yoseloff of A. S. Barnes and Company has kindly granted permission to reproduce *Fragment of a Ming Painting*. The Museum of Modern Art has permitted the reproduction of a number of works from its collection, credit lines for which appear with the illustrations. American Archives of World Art has supplied *Harlequin's Carnival* by Miro and the *Detail of Empress Theodora*.

I wish to thank Dr. Tom Burnam for reading and correcting an early draft of the manuscript, and W. N. Hale of the Munsell Color Company for his helpful suggestions. I am especially grateful to my wife, Lucille, for much valuable advice and assistance.

RICHARD G. ELLINGER

Paperback edition published in 1980
Copyright © 1963 by International Textbook Company
Library of Congress Catalog Card Number 79-57209
ISBN 0-442-23941-6

Designed by Angelo D. Rinaldi
Printed in the United States of America

Van Nostrand Reinhold Company
135 West 50th Street, New York, NY 10020, U.S.A.

Van Nostrand Reinhold Limited
1410 Birchmount Road
Scarborough, Ontario M1P 2E7, Canada

Van Nostrand Reinhold Australia Pty. Ltd.
17 Queen Street
Mitcham, Victoria 3132, Australia

Van Nostrand Reinhold Company Limited
Molly Millars Lane
Wokingham, Berkshire, England

16 15 14 13 12 11 10 9 8 7 6 5 4 3 2

Preface

Color presents many faces to her investigators. Research by physicists, chemists, psychologists, and other scientists, each working from the premises of his particular discipline, has illumined many of her faces, though some still remain in shadow. The face which color presents to the artist is one which perhaps will always be partially shadowed.

The study of human response to the color stimulus is, by reason of the emotional involvement of the investigator, not readily probed by the methods of science. Nevertheless, it is this face of color which is closest to the common experience of all of us and with which everyone who works creatively with color must deal.

In this book I have tried to establish a rationale of color organization upon which the creative worker may rely. In effect, it establishes the orderly frame within which the personal and emotional directives of the designer may play freely. It is an approach to color composition which, I believe, is both sound and basic to our understanding of colors in combination.

RICHARD G. ELLINGER

Greeley, Colorado
May, 1963

Contents

Introduction

The organization of color is an important part of the designer's problem. Everyone who works creatively with color needs a sound understanding not only of the resources of his colors and their expressive potentials but of the means and techniques of ordering his color so that he can convey his personal expression in its most effective form. This book is designed to give such help. It is a practical book on color composition, based upon the writer's long experience in the teaching of color to college students.

The book's title, *Color Structure and Design*, implies that there is structural order underlying effective color expression and that such order is based upon the laws and principles of design. The validity of this concept will be amply demonstrated in the text, yet the total problem of creative color cannot be so easily summed up. There is, for example, untouched by this summation, the highly significant capacity of color to carry expressive meaning.

Let us consider for a moment what this means to the creative colorist. In company with all visual elements of design, color provides certain visual stimuli which impinge directly upon the sensory organ of vision and so speak directly to the emotions without intellectual intervention or interpretation. Thus, we *feel* the excitement of colors which are lively and gay, the restful mood of quiet harmonies, or the violence of harsh conflicts. This direct sensory appeal to the emotions is, of course, the potential which gives to color its status as a vehicle of artistic expression.

The appropriate emotional meaning to be conveyed by color is determined in reference to the purpose and function of the particular project. Thus, the color of a living-room interior might be planned to give the feeling of quiet serenity, or, perhaps, of sparkling animation; the stage decor for a lively revue might require an expression of vivacious gaiety, while that of a tragic drama might seek an expression of somber foreboding.

The emotional meaning is the heart of the expressive potential and constitutes the substance of what we can say with color. How we say it is a matter of technical organization, or the problem of form; for whatever we say with color needs to be presented in such a way that visual unity results.

Good color achieves both of these significant objectives. First, it conveys a meaning at the emotional level by expressing a feeling appropriate to the function and purpose of the project in hand. Second, it achieves, through the organization of the stimuli presented, a visual unity or oneness. The solution to both aspects of the problem demands, quite obviously, some technical understanding.

If the foregoing is a fair statement of the problem, dare we leave the matter of creative color entirely to our intuitions and what is known as "good taste," as is frequently recommended? Certainly our emotional directives, our intuitions, our feelings, are highly important in the creative process. Indeed, they are primary in every creative endeavor; yet they need the chastening of the intellect, which contributes a technical knowledge of means and resources of the color medium and of the organizational techniques for achieving visual unity.

In the view of the writer there is a reason for good color. Its distinction is not based upon whim or personal fancy, although within the province of organized color the personal and emotional directives of the designer may, and should, play freely. To repeat: color is good when it is expressive of the emotional goals appropriate to a particular project and when it is presented in accord with the human demand for order. The nature of this demand, and the certain kind of order it requires, will lead us into a consideration of basic design theory. We shall see that color is part of the larger problem of form and that the color factors are as elemental to that form as are line, shape, mass, and texture.

Certain laws, or principles, of design structure, to be discussed later, have been found not only to be pertinent to the organization of color and the other elements of visual form but to be valid throughout the field of creative arts. In effect they define the broad structure of the art form regardless of the medium. They establish the conditions under which sensory stimuli may most effectively be presented.

The operation of these principles—long known to art students and professional designers in relation to such elements of form as line, shape, mass, and texture—will be found equally applicable to color. However, as we shall discover, the complex manifestation which we call color must first be clarified to reveal its three separate ranges of variability, each of which will be found to be an elemental factor of form and separately subject to the principles of order.

It is the purpose of this book to alert the colorist to the emotional implications of his problem and to provide him with the intellectual tools, the technical knowledge of structure, which will enable him to achieve the formal unity and maximum effectiveness of his color creation.

In the first several chapters of this book we shall deal with fundamental concepts of color, including a descriptive terminology based upon the Munsell system. Chapters 5 and 6 introduce a basic theory of design with its implications for the organization of color. The place of color in the broader view of the design problem is considered in Chapter 7. Here the design elements, line, shape,

mass, and texture, which inevitably accompany the color factors are presented, together with organizational techniques for handling them.

Chapter 6 introduces the first of a series of creative exercises in which the student is urged to participate. Starting with the simplest of color schemes, the field of color is probed step by step in a series of projects in ever-increasing ranges of hue.

The serious student of color should plan to work creatively as he studies the text, developing his own solution to each problem in sequence. Any pigment medium such as oil color, casein, or colored chalk will serve the purpose, but perhaps the most satisfactory for student use will be tempera paint, also known as show card color.

The final chapter surveys several leading color systems and discusses their virtues in relation to the needs of the creative worker.

The color plates which accompany many of the chapters were chosen from historical as well as contemporary sources to illustrate the various types of color order discussed in the text. They represent a variety of cultures and art styles. Some of them are student solutions to the projects proposed in the text. All of them demonstrate the thesis of this book—that fine color is based upon sound structure. Most of them are accompanied by analyses which should assist the reader in his understanding of the art form of color.

Some Basic Concepts

Before we can discuss the creative problem, there are a few fundamental truths and concepts concerning color which demand recognition. We should know what color is, the respective roles of light and pigment, and how the eye functions in response to the color stimulus. We should become acquainted with a simple terminology for the classification of the qualities of color, together with a graphic means of charting their ranges of variability.

THE NATURE OF COLOR

In a real sense color exists only as vibration of light. Whenever we receive the sensation of color, we do so because certain vibrations of light are meeting our eyes. If we remove the light source, the color vanishes. If we change the quality or strength of the light source, the color changes also.

The human eye, the instrument of vision, is so constructed that it receives but a small segment of the total range of nature's vibrant energy. The vibrations to which the human eye is attuned are those of light.

When the whole visible range of light vibrations is active in balanced proportion, we receive the sensation of white light. This is the composition of the ordinary (but miraculous) light of day.

Sir Isaac Newton discovered that when he passed a beam of sunlight through a glass prism, the white light broke into a brilliant array of colored bands, later known as the *spectrum*. When these colored bands were reunited by means of a reversed prism, the beam of white light was restored.

Newton's experiment clearly demonstrated that white light is a compound of the many colors which compose the spectrum and that the particular vibrations of anyone of them are present in the total complex of white light.

The distinctive color variation noted in the spectrum is known as *hue*. The various hues of the spectrum have the common names known to everyone. At one end of the spectrum, red, with the longest wavelength, vibrates at the lowest frequency, or number of vibrations per second. Progressing through the spectral range, as wavelengths become shorter and the frequency increases, the eye registers a progressive change in hue sensation, passing through the yellows, greens, blues, and finally the purples.

We may receive a color sensation directly from a light source when we look through a stained-glass window or at a traffic signal, but more commonly we see color as a reflection of light from a pigmented surface. In either case the medium of pigment is involved in the translation of the white light source into the colors which we see.

THE NATURE OF PIGMENT

A pigment is a substance which has the unique capacity to reflect (or transmit) a limited portion of the vibrations of the spectrum. (White pigment, however, reflects the whole spectral range.) Pigment can reflect (or transmit) only the vibrations to

which it is attuned. When pigment cannot receive its own kind of light, it appears neutral gray and without hue.

When a red-pigmented surface receives white light, it reflects only the red portion of the spectrum to the eye. If the red pigment were to receive only blue or green light, it would appear neutral, since there would be no red vibrations to reflect.

When a white light shines through a red-pigmented gelatin, only the red vibrations come through. What happens to the other vibrations is not clearly understood. In some way they are absorbed or nullified by the pigment substance.

When pigmented surfaces are combined for artistic purpose, the colors which we see are the result of light vibrations reflected from the pigmented surfaces. In other words, even though pigment is an intermediary factor, the sensation is always a phenomenon of light.

THE HUMAN EYE IN RELATION TO COLOR VISION

It is important to know something about the sensitive visual instrument which receives the vibrant message and conveys it to the brain as the sensation of color.

The eye does not report the qualities of color in an absolute sense, in the way we might expect of a piece of laboratory equipment. It is highly adaptable to relative qualities of color, so that the color reported to the brain, the apparent color, is always conditioned by the surrounding and neighboring color areas.

The following examples demonstrate the adaptability of the human eye to situations of varying contrast.

In Figure 1, the same gray is shown against two different, contrasting backgrounds. The apparent gray is lighter against the dark ground and darker against the light ground.

In Figure 2, the same neutral gray appears against two different backgrounds. Against the red background, the gray takes on a faintly blue-green tinge. Against the green-yellow, it looks faintly purple.

Similar slight shifts in the apparent hue occur whenever two color areas are juxtaposed. A true green, for instance, will read as a slightly bluish green when placed next to yellow or orange,

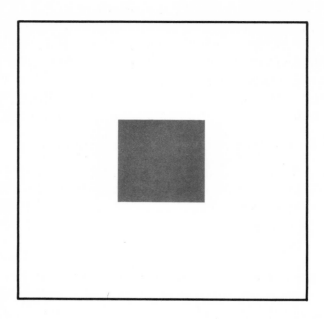

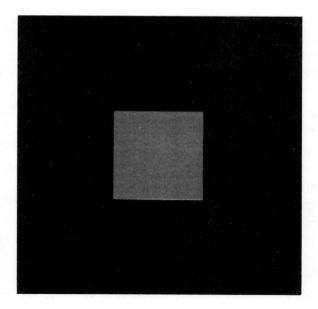

Figure 1

while the same green in company with blue and blue-green will read as a slightly yellowish green.

The foregoing peculiarities of color vision are aspects of the phenomenon known as *simultaneous contrast*. The effect of this phenomenon is to exaggerate the color differences of adjacent color areas, and it is operative in respect to all of the qualities of color. The present demonstrations, however, are sufficient to indicate that color sensation is a relative rather than an absolute reality.

ROLE OF THE EYE MECHANISM IN ESTABLISHING COMPLEMENTS OF HUE

In the situation demonstrated in Figure 2, where a strong color area is contrasted with a neutral gray, the eye itself designates the hue which appears in the gray area. If we carry the demonstration to the point of fatiguing the eye by steadily gazing at the strong color for a minute or two—for example, at the red in Figure 2—the gray spot will soon read as a vivid blue-green.

If the gaze is shifted to some fairly neutral area after being thus fatigued, the image of the red area will persist as an *after image* but will read as blue-green. The blue-green, therefore, is the hue which the eye designates as the opposite, or complementary, hue to red. In the same manner, the complements can be determined for all hues in the spectrum.

It would seem that the eye structure has a built-in demand for an equilibrium of hue sensation which must be accommodated if we are to avoid fatigue and temporary impairment of color vision. This points to the necessity for basing oppositional relationships in color planning upon the known behavior of the eye mechanism.

THE CHARTING OF HUE RELATIONSHIPS

Because the eye designates the oppositional or complementary nature of certain pairs of hues, the charting of hue relationships is facilitated by bending the spectrum scale into the shape of a circle, thus diametrically opposing the complementary hues so designated by the eye structure, Figure 3.

For convenience and simplicity the diagram places five hues equidistantly around the circle, but we should understand that

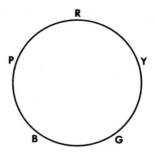

Figure 3

intermediate hues lie between. BG (blue-green) lies between B and G; GY (green-yellow), between G and Y; YR (yellow-red), commonly called orange, between Y and R; RP (red-purple), between R and P; and PB (purple-blue), between P and B.

Since this arrangement of hues is based upon the perceptual experience, it will be valid for charting hue relationships of colors as we see them. It is also a valid chart for recording mixtures of colored light.

But colors may differ from each other in other respects than hue. Common experience indicates that colors vary in degree of lightness or darkness and also in degree of dullness or brightness. A color that is red in hue may be a light red or a dark red, and it may also be a dull red or a bright red. To describe a color, we need to indicate not only its hue but also its degree of lightness or darkness and its strength of pigmentation.

In nontechnical language we might describe a particular color as a dark, dull red; a light, pale yellow; or a light, bright yellow. Such common descriptions of color may serve the layman's purpose well enough, but for a more specific definition of color qualities we need to use a more technical and accurate terminology.

A number of systems for labeling and classifying the ranges of color variation have been contrived. Of these, one of the simplest and most immediately useful for our purpose is the Munsell color system.

In the next chapter we shall study certain aspects of the Munsell system, together with other useful concepts which will help us to understand the technical structure of the field of color.

The Dimensions of Color

Of the several available systems which seek a way to chart and describe the potentials of color, the Munsell plan offers a simple and adequate means of color description and classification. It is based upon measured qualities of colored light, and since in color composition we are dealing with colors as they are seen together, that is, as colored light, the charting of color relationships on the Munsell plan is extremely pertinent. Systems based upon the behavior of pigments are not entirely adequate from the standpoint of charting visual relationships.

We should, however, understand that the variable potentials of color are constant and demonstrable phenomena regardless of the means chosen for systematic classification and description and that the problem of visual order remains the same regardless of the descriptive terminology we might use. For a comparative survey of several widely used color systems, those of Ostwald, Ross, and Munsell, see Chapter 17.

11

Munsell uses the terms hue, value, and chroma to specify the three qualities which describe a color. *Hue* specifies the quality of color variation noted in the spectrum. We have already discussed the hue-circle diagram, Figure 3, upon which hue variations may be charted.

Value specifies the degree of lightness or darkness of a color measured in relation to a graded scale from black to white, Figure 4. Munsell uses numerical terms to indicate degrees of value; black, at the bottom of the scale, is value 1; white, at the top of the scale, is value 9. The Munsell value scale makes provision for an extension of the scale to value 10 to accommodate a theoretically pure or absolute white, and to value 0 for a theoretically pure or absolute black. However, for most purposes, we need be concerned only with the range of value shown in the diagram. The named steps of the value scale are those proposed in the Ross system (see Chapter 17). The terms *light, middle,* and *dark* are especially convenient names for values 7, 5, and 3, respectively.

Chroma is the term used by Munsell to indicate the quality of brightness or dullness of a color. The range of chroma extends from neutrality, or grayness, to the brightest and most intense color that a pigment can give. This quality is readily understood as intensity, or the strength of pigmentation.

Chroma may be charted, along with hue, on the hue circle, Figure 3. The center of the circle represents neutrality, or the zero of chroma. The degrees of chroma are indicated on any radius of the circle progressing outward from the neutral center through the areas of low chroma, middle chroma, and high chroma to the periphery, where the highest chroma is charted. Thus, any point within the circle registers not only hue but the degree of chroma.

Munsell provides numerical indication for the degrees of chroma from 0 to 16. A few special colors have chromas above 16. As new and stronger pigment sources are developed we can expect the chroma range to increase to accommodate them. However, for practical purposes, the terms "low chroma," "middle chroma," and "high chroma" are usually sufficient.

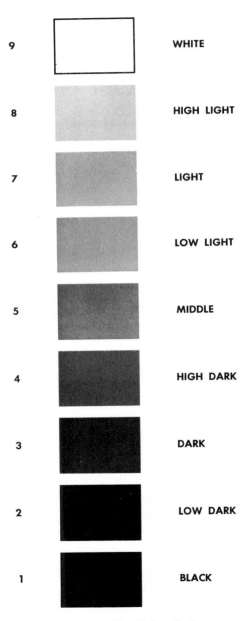

Figure 4. The Value Scale

We should further understand that the three qualities hue, value, and chroma are coexistent in every spot of color and together provide its accurate description.

MUNSELL'S COLOR NOTATION

In order to describe more precisely the hue quality, Munsell divides each hue section of the hue circle into 10 parts, numerically indicated from 1 to 10 going clockwise around the hue circle. This, in effect, enables us to define 100 different hue distinctions. Hue divisions beyond 100 are indicated by adding decimal fractions to the numerals. In the notation, the numeral precedes the letter for the hue. Thus 5R indicates the red which lies in the center of the red sequence; 2R indicates a red tending strongly to RP; and 10R indicates a red bordering on YR.

Value and chroma are indicated numerically; the value above the line, the chroma below. Thus, notation 5R 4/14 indicates a red at value 4 and at chroma 14.

THE COLOR SPHERE

To illustrate interrelationships of the three ranges of color variation and to show the potentials of the entire field of color, a three-dimensional chart would be required. Munsell has for this purpose suggested the sphere, Figure 5. While it does not pretend to portray the color potentials in complete accuracy, it does provide a useful concept of the ordered relationships of the total color field.

The ten hues of the hue circle are represented as segments of a sphere grouped around a vertical axis, each segment embracing the value and chroma possibilities of a single hue. The axis of the sphere represents neutrality, the completely hueless (and chromaless) range of grays from black at the lower pole to white at the upper. Degrees of value are indicated in progressions latitudinally from bottom to top; the darker values below the equator, the lighter ones above.

Colors on the surface of the sphere are represented as at their highest chroma, or greatest intensity, for any given value. Chroma

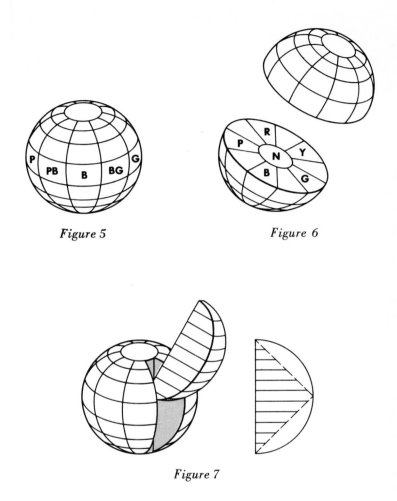

Figure 5 Figure 6

Figure 7

variation is measured horizontally from the neutral core, or axis, outward to the surface. If we should slice through the color sphere at the equator, Figure 6, we would discover, of course, the hue circle, previously discussed, upon which hue and chroma relationships may be charted.

If we remove a vertical segment of the sphere, Figure 7, we may derive another useful device, the triangular chart, which roughly describes the value and chroma potentials of a single hue. This chart will be discussed later as the *constant-hue chart.*

It will be noted that the triangular chart derived from the sphere segment shows the farthest reach of chroma at the outer point of the triangle which, of course, lies on the equator of the sphere at middle value. But this is not true for all hues. The chroma potential not only varies with the different hues but reaches its highest chroma at different levels of value. Yellow, for example, reaches its highest chroma at value 8, whereas red attains it at value 4.

As a correction to the color sphere, to accommodate this variation, Munsell proposed a device called a "color tree," whose branches extend outward from the central axis of the sphere at the level of highest chroma for each hue. For our purpose, however, the triangular diagrams, adjusted to the chroma potentials of each hue, will accomplish the same end. It will, of course, be essential to know at which value level each hue may achieve its maximum intensity. This we shall learn in making the scale of *spectrum values* discussed in the next chapter—a chapter devoted to the resources and behavior of pigments.

The Resources of Pigment

Pigment, as we have seen in Chapter 2, is a substance which has the unique capacity to select and reflect a limited band of the light spectrum and at the same time to cancel or destroy the vibrations which it cannot reflect. Although we use pigment to produce the colors which we see as colored light, the pigment stuff itself is obviously a physical substance quite different from light, and its behavior in mixture might be expected to differ from the behavior of light. Actually, the physical principle involved in pigment mixture is radically different from that involved in light mixture. In scientific terms light mixes according to the additive principle and pigment mixes according to the subtractive principle.

These technical terms are more readily understood if we accept them at their face value. A mixture of colored light is the sum, or simple addition, of the light vibrations involved; a mixture of pigment is the remainder after the pigments have exerted their negative, or subtractive, force upon each other.

Light mixtures are charted upon the light circle with which we are already familiar. Since light mixture is a rather special prob-

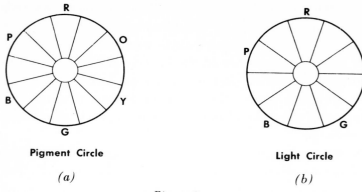

Pigment Circle

(a)

Light Circle

(b)

Figure 8

lem which mainly concerns operations where colored lights are used, we shall delay discussion of this phase of color until Chapter 13. The discussion of pigment mixture, however, requires some elaboration at the present time.

The negative power of a pigment to destroy the force of another is central to our understanding of pigments in mixture. The most dramatic demonstration of this power occurs when complementary pigments are mixed. Each destroys the other and the resulting mixture is a neutral gray. Indeed, this is the test used to determine pigment complements.

It is not surprising to discover that we need a special hue circle for charting the behavior of pigments. Such a circle is shown in Figure 8a. Note the extension of the distance between R and Y, allowing for intermediates on either side of orange, and note also the changed alignment of complements. Counting the intermediates OR, YO, GY, BG, PB, and RP we have a total of 12 hues for the pigment circle as compared to the 10 hues of the light circle, Figure 8b.

The pigment circle is a reliable device for charting pigment mixtures. A line drawn between any two points on the circle indicates the path of the mixtures of these pigments. If, for example, we draw a line between Y and B, we will see that the mixture path crosses the green sector. To understand why yellow and blue pigments produce a green mixture we need to look further into the nature of pigment.

The portion of the spectrum which a pigment can reflect is actually a limited band of hue vibrations rather than a precise point. A pigment, therefore, reflects overtones of its neighbors on either side of its position on the hue circle. When any of these marginal hues find support in the overtones of the pigment with which they are mixed, their combined strength dominates the mixture, and the original pigments, sapping each other's strength, are submerged.

In the present illustration the yellow pigment has a capability of reflecting a certain amount of its neighboring hue, GY. The blue pigment has a capability of reflecting a certain amount of BG. Thus, both pigments have a common capability of reflecting some green light. Their combined capability makes green the strongest force in the mixture while pigments B and Y rob each other of their original power and approach neutrality. The presence of this neutral body in the mixture naturally reduces the chroma strength of the mixture to less than that of the original pigments.

An instructive demonstration of the difference in the behavior of light and pigment will be seen in the following experiment. If we should pass a beam of white light through a red-pigmented gelatin, the red pigment, of course, would destroy all of the hue vibrations except the red which would come through the gelatin as red light. If we now attempt to pass this red light through a green gelatin we shall find that no light whatever will come through. The green pigment in the gelatin will have subtracted, or destroyed, all of the red light.

But, if we place these same gelatins each over a separate white light source—giving us a green light and a red light—and train them upon the same area of a projection screen, we will be mixing light, not pigment. The color on the screen will be a brilliant yellow, the result of the addition of the green and red vibrations as shown on the light circle.

It should be clearly understood that the pigment circle is used only to chart pigment mixtures. For this purpose it is reasonably accurate and necessary, but for the broader purposes of color composition—the charting of colors which are to be seen together as a color scheme—we must use the light circle, which takes

account of the hue balance in accordance with the perceptual experience. In other words, we mix pigments according to the *pigment* circle but we organize our color schemes according to the *light* circle.

To produce colors of whatever desired qualities, pigments are mixed according to the following general principles:

1. Hue change, with little loss of chroma, can be effected by a mixture of pigments which are neighbors on the pigment circle.

2. Value change is achieved by mixtures with white or black, which result in little change of hue but appreciable reduction in chroma, or by mixtures with lighter or darker pigments, in which case all three color qualities will be affected.

3. Chroma may be reduced without change of hue by mixtures with the pigment complement or with the neutrals. Chroma may be increased only by the addition of a higher-chroma pigment. Since any mixture of pigments reduces chroma, indiscriminate mixing of many pigments inevitably kills the chroma potential. It is therefore advisable to mix purposefully, using as few pigments as possible to produce the color quality desired.

SPECTRUM VALUE

Since chroma is easily reduced but cannot be increased except with a stronger pigment, the pigments you purchase state the highest chromas available to you. If you examine your assortment of pigments, you will notice that the intense colors vary in value. The bright yellow comes at a high value; the bright red, near the middle or below; etc. It is important to know the value at which a given hue may achieve its highest chroma. This value is known as the *spectrum value.*

The spectrum values of the different pigments follow a pattern of physical law, since they are part of the orderly physical universe. The order of the spectrum values can be clearly perceived if we set a spot of each of our intense pigments at its own value

The spectrum-value scale is important because it shows the value levels at which the various pigments can achieve their highest chromas. It shows the value level for the outer point of the triangle of the *constant-hue chart,* soon to be discussed, and it is therefore basic to the understanding of the resources of each pigment.

PROJECT 1

OBJECTIVE. To make a scale of spectrum values.

TECHNICAL DIRECTIONS. First make the value scale in neutrals as directed below, then set the bright pigments at their respective value levels on either side of the value scale as shown in Figure 9.

PROCEDURE. Make the value scale with mixtures of white and black. Start with middle value (value 5). This value should make equal contrast with white and black. Experiment with mixtures, checking accuracy by observing the mixture in immediate contact with spots of white and black. If, when making this test, the three spots appear as two light spots and one dark, the mixture is too light. If the three appear as two dark spots and one light, the mixture is too dark.

When a true middle value has been achieved, mix some of this with black to achieve value dark (value 3) and with white to achieve value light (value 7). From these mixtures the intermediate values can readily be produced.

To complete the scale of spectrum values indicated in Figure 9, mix neighboring pigments as necessary to produce the full scale of hues and place them at their appropriate value levels on either side of the value scale. There are a few places where the pigments may not seem to follow the order indicated. For example, your set of pigments probably does not have an intense pigment for RP and for P at the values indicated. In fact, even an artist's palette lacks a strong deep purple. However, the implications of order established in the rest of the spectrum-value scale lead us to suspect that when, and if, a strong pigment source for purple is discovered, it will be a very dark pigment.

A strong RP, known as magenta, appears at a higher value than the scale indicates, but an equally strong RP pigment, known as alizarin crimson, appears at the expected value.

The common pigment source for blue is known as ultramarine blue, and this is probably the pigment that is in your tempera set, labeled blue. This blue, however, has a purplish cast to it. It is in reality PB and should be so placed. (On the Munsell hue circle the space given to each hue is centered upon the hue quality which tends neither to one neighbor or the other.)

THE CONSTANT-HUE CHART

Now that we know the value at which each hue can achieve its brightest chroma (see Figure 9), we are ready to return to the consideration of the triangular chart referred to at the end of the preceding chapter. The triangular chart is a convenient device for showing the value and chroma potentials of a single hue. It is known as the *constant-hue chart*.

Figure 10 shows the constant-hue chart for red. The vertical staff at the left represents the zero of the chroma scale. It is a value scale in neutrals like the one used in the spectrum-value scale. The outer point of the triangle, which falls at value 4, Figure 9, represents the point of highest chroma for red. The second vertical column from the left represents the potential value range at low chroma. The third vertical column represents the potential value range at middle chroma; and the next, the more limited value range at high chroma. At the point of highest chroma there is only one value possible.

The area enclosed by the triangle roughly defines the limit of resource for a given pigment. Colors outside the triangle are non-existent, that is, cannot be produced by pigment. It is as impossible to produce a bright red at value 8 as it is to produce a bright yellow at value 4.

For the purpose of understanding the resources of a single hue, as well as to get experience in purposeful mixture of pigment, it is recommended that the student make a skeleton constant-hue chart of a pigment of his choice.

PROJECT 2

OBJECTIVE. To make a skeleton constant-hue chart.

TECHNICAL DIRECTIONS. It is essential to have a value scale of neutrals as a guide to the value levels. The neutral scale also represents the zero of the chroma scale and appears as the first column in Figures 10 and 11.

Make your choice of pigment and place the full-strength pigment at the outer point of the triangle at its own value level. Complete the scale as indicated in the following illustration.

PROCEDURE. Suppose the pigment chosen is yellow. The bright-yellow pigment, when checked against the value scale, will be found to be at value 8, the spectrum value of yellow. Place a spot of bright yellow at the outer point of the triangle, at value 8, as in Figure 11.

Now produce the chroma series at this same value by mixtures with a neutral gray of value 8; thus, a middle, a low, and a high chroma. With yellow, pigment mixtures with neutrals tend to shift in hue toward green. This is because the black pigment in the mixture is not strictly neutral, but slightly bluish in tone. Refer now to the pigment circle. A line drawn from Y to a neutral off center toward the blue would cut across the field of low-chroma greens. To avoid this distortion, the neutral needs to be corrected to true neutrality by the addition of a small amount of orange.

Mixtures of the original pigment with increasing amounts of white give the upper contour of the triangle. Mixtures with black (corrected as indicated above) give the lower contour of the triangle. Now at each value level, where a chroma stop has been made, fill in the interior of the triangle so that each horizontal row is of equal value and each vertical column is of equal chroma.

It will be observed in this exercise that there are many beautiful possibilities of color in the interior of the triangle and that simple white or black additions to the original bright pigment produce only the variations seen along the outside contour of the triangle.

To produce the horizontal (equal-value) sequence of chroma, the control pigment N should be established at the intended value before mixing. The same should be done if a complementary pigment is used for reducing chroma.

For example, if the pigment complement P is used to reduce the chroma of the yellow, the purple pigment (having a low spectrum value) must be raised to value 8 by a great addition of white to produce the chroma series at this value. Purple at this value is so neutralized that there is little difference whether chroma reduction is accomplished by the complement or by a neutral gray at value 8.

Where the opposing pigment can have even a moderate chroma strength, it is generally preferred for the purpose of chroma reduction, since the interplay of complementary particles of pigment tends to produce a livelier, fresher quality. This fine point, however, will be scarcely discernible in the mixtures of the show card tempera.

A Basic Theory of Design

In the preceding chapters we have identified the three variable qualities of color, hue, value, and chroma, and have seen that each is a unique and separate visual stimulus with its own fixed range of variability.

Let us now consider the problem of combining these color qualities for artistic purposes. There are, as discussed in Chapter 1, two important goals to be achieved. First, the colors must convey an expressive meaning appropriate to the particular project for which a color solution is sought. Second, these same colors must be so presented to the observer that a visual unity will result.

Quite obviously, both aspects of the problem require some technical understanding. Let us first consider the structural

requirements for the achievement of a visual unity. (After we understand the organizational structure of the color scheme we can more easily master the techniques involved in the expressive aspects of the problem. The expressive phase of the problem will be considered in later chapters, especially Chapter 13.)

The goal of visual unity is a constant for all workers in the visual arts. The designer exerts control over the visual qualities of form so that his creation may be received as a unity by the observer. Design unity becomes the goal of his presentation. Whatever he may seek in terms of expressive values must meet the requirement of unified presentation.

RATIONALE OF DESIGN THEORY

For the designer, visual form is composed of certain properties such as line, shape, mass, texture, and the qualities which define color. These varied aspects of form are known as the *elements of form,* or the *elements of design.* It is important to observe here that the three variables of color separately represent elemental aspects of form.

Since each of the elements presents a separate and unique visual stimulus and has great potential in variation, it becomes necessary for the designer to exert certain controls in the interests of order and visual clarity.

Since the impact of the elements is received directly through the sensory organ of vision, the emotions are directly involved. The feelings of the observer in response to the stimuli become the arbiter of the designer's success. The problem of theory is to discover the conditions under which the emotional responses are freely receptive and affirmative. The theory of design is based upon the assumption that our emotions demand a certain kind of order in the stimuli presented.

LACK OF A COMMON TERMINOLOGY

Design theorists have proposed a number of concepts which embody the kind of order demanded for visual unity. These are known as the *principles of order,* or the *principles of design.* Writers in this field are prone to invent their own terminology, so

that, in spite of considerable agreement, the names assigned to the principles show a wide variation.

Thus, the principle concerned with the presentation of opposing forces is variously referred to as balance, opposition, contrast, or even symmetry. The principle concerned with related movement appears as rhythm, sequence, repetition, gradation, transition. The principle concerned with the resolution of conflict is given as dominance, domination, subordination, or harmony. Presumably all such principles are considered as means to the end goal: unity. To find unity proposed as a principle, as it is in some listings, confuses the categories of means and ends and is to that extent misleading.

Many writers discuss design principles in relation to such elements as line, shape, mass, and texture but fail to consider their application to color. Color is regarded as a single element, evidently too complex for design principles to handle. Indeed, it is only when color is recognized as a complex of three separate variables, each with elemental status, that the application of the principles becomes pertinent to color.

NEED FOR CLARIFICATION OF THEORY

Perhaps it is too early to hope for a commonly accepted terminology; yet some clarification of terms, if not philosophy, is patently needed at the present time. Any attempt at clarification should come as the result of honest appraisal of the factors demonstrably present in the designer's problem. If we look broadly at the problem, we must see that, on the one hand, there are the visual stimuli provided by the elements and, on the other, the perceptive human faculties which receive the stimuli and react to them with emotion. The crux of the matter lies in the way we, as human beings, actually respond to presented sensory stimuli. If we can find the simple constants of human response in this situation, we shall have a valid basis for design theory.

In the following exposition simple human traits underlie the proposed principles and establish a rational basis for the organizational demands of theory.

PRINCIPLES OF DESIGN

Limitation

First of all, as human beings exposed to the visual stimuli, we are, let us admit, easily confused. Disorder occasioned by unrestrained diversity can be nothing but emotionally repellent. We have a limited tolerance for diversity. There must be some limitation upon the ranges of diversity if we are to be emotionally appeased.

Balance

A second human demand is rooted in our emotional response to tedium. We are easily bored. We can easily get too much of anything. Emotionally, we demand relief whenever monotony threatens. We demand the play of opposing forces. Let us encompass this human demand in the design principle we shall call *balance*.

Dominance

Although we demand the play of opposing forces (as provided by the principle of balance), the opposition of equal forces creates tension and strife, precluding a sense of oneness. For emotional satisfaction we demand that a winner be declared. To embody this demand for the resolution of the conflict, let us use the principle we shall call *dominance*.

Rhythm

A fourth emotional demand concerns the need for continuity and ease of passage throughout the whole presentation so that it may be summed up visually as a consistent whole. This demand is perhaps less pertinent to the color statement than to certain other visual elements. For the sake of simplicity we shall delay consideration of this human demand until Chapter 12, where we shall meet it as the principle of *rhythm*.

THE VALIDITY OF THE PRINCIPLES

The principles suggested above are simple and demonstrable commentaries on the way human beings respond emotionally to

sensory stimuli. We should, therefore, expect the finest color presentations of the ages to give visible proof of the order embodied in the above principles. We should expect to find, for example, that the fine color of the Persian miniaturists and of the Venetian painters of the Renaissance (as well as the work of modern masters of color) will yield, upon analysis, the evidence of such ordered presentation. And this is precisely what we shall find as we learn to observe the evidence contained in such works of art. That the language of art should be universal should not surprise us when we consider that human emotional response is also both a constant and universal.

THE APPLICATION OF THE PRINCIPLES

We have observed that the foregoing principles of design owe their validity to a few simple emotional demands, demands for a certain kind of order in all presented stimuli. The principles embody these demands and therefore state the conditions for the most effective presentation of the visual stimuli. For the designer they become intellectual tools for the ordering of each visual element.

Since the design principles indicate the basic relationships of the color factors which are essential to the achievement of visual unity, they define the structure of the art form of color. Let us now interpret the principles in relation to the three ranges of color variability.

The principle of limitation is usually taken for granted by writers on design theory; nevertheless, it is an important positive control and deserves recognition as an active means of imposing order. The principle of limitation functions to restrict the range of variability in one or more of the color dimensions. It is optional according to the needs of a particular problem, provided that some limit upon the total field of color variation is imposed. Thus, a color scheme within a restricted range of hue might, with impunity, flaunt unrestricted ranges of value and of chroma.

The principle of balance enforces the demand for oppositional groups within each range of color variability, and it achieves its objectives as soon as oppositional forces are clearly identified. This

means that we must have opposing groups of hues, opposing groups of values, opposing groups of chromas. In the interests of clarity and economy of means the oppositional nature of the color forces must not be clouded or made ambiguous by the inclusion of intermediates which might destroy the drama of difference.

The principle of dominance proclaims the need for the resolution of the conflict between the opposing forces. The conflict must be resolved in favor of one or the other in each set of contending forces. This is accomplished by granting greater representation (greater total area) to one of the contending groups in each category and, of course, less representation to its opposition. One hue, or group of related hues, must be dominant over the opposing hues in the color scheme. One value, or group of related values, must be stressed over other values. One chroma, or group of related chromas, must be given preference over other chromas.

In each case dominance is established by the device of allotting to the chosen group the major portion of the total area of the unit. Since all three color qualities coexist throughout the total area of the unit, the total area is involved in each case of division between the dominant and subordinate groups.

The amount of the total area necessary to establish a dominance will be learned through experience and a sensitive response to the needs of unity in a given color scheme (see also Chapter 9). Since the dominances state the main character of a color scheme, it is important that each declare itself clearly. As long as the dominances achieve sufficient area to make such declaration, they give us no trouble at all. The trouble spots occur in the handling of the oppositions; but this problem will be discussed in later chapters.

Specific Controls of Color and the Graphic Devices for Charting Them

The design principles, as presented in the preceding chapter, state ways of imposing order upon the three variable aspects of color. Since each principle is applicable to each of the color qualities, we have, in effect, nine specific controls for the ordering of color.

It has seemed advisable to give in one place the list of these important controls, together with adequate descriptions and the graphic devices for charting their effects. As the headings indicate, these controls simply detail the action of the design principles in respect to each of the color variables.

LIMITATION OF HUE

The term signifies limitation upon the range of hue. By restricting the extent of the hue range, we impose order upon the color unit.

Hue limitation can be indicated on the hue circle by placing boundary lines around the designated portion of the hue field and by shading the section for clear reading. Figure 12 shows the charting of three different hue limitations. The various types of color schemes are conveniently named according to the type of hue limitation involved. Thus, at (a) is shown the single hue and neutral scheme; at (b), the adjacent hues and neutral scheme; and at (c), the single hue and its complement.

The concept of limitation concerns *the extent of the range* included in the scheme. The principle of limitation, however restrictive, must always allow sufficient range for oppositional groups to be identified.

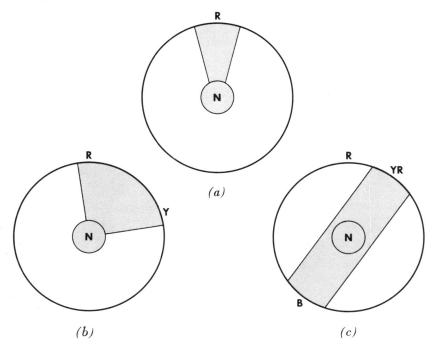

Figure 12

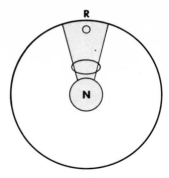

Figure 13

BALANCE OF HUE

This term refers to the balancing of the hues on one side of the color field with those on the other. In effect it is concerned with the provision for opposing groups of hues. Hue balance may be achieved in other ways than by the opposition of complements. Neutrals, for example, may serve as hue balance in opposition to a single hue or to a group of adjacent hues. The triad scheme achieves hue balance in a triadic opposition of hues.

In practice it is convenient to consider the subordinate hue group (the hues which are providing the opposition to the hue dominance) as the hue balance.

DOMINANCE OF HUE

In order to resolve the conflict between opposing hue groups, one group is given the major share of the total area, thus giving it dominance over the other. Hue dominance may be established upon a single hue or upon a group of related (neighboring) hues.

In charting, the hue dominance is indicated by a large ellipse or circle and the subordinate hue by a small circle. Figure 13 charts a single hue and neutral limitation. Note that upon the hue-circle diagram every point registers both hue and chroma. The large ellipse, while denoting that the hue R is dominant, also indicates that the low chroma is dominant. (The hue balance in this case is achieved by the neutral; chroma balance by both the high chroma and the neutral.)

(a)　　　　　　　　*(b)*　　　　　　　　*(c)*

Figure 14

LIMITATION OF VALUE

This term signifies a limitation imposed upon the range of value. Figure 14a charts a value range in which the darkest value is 5, or middle value, and the lightest value is 9, or white. (The large ellipse, of course, indicates that the dominance of value is placed at about value 7. The smaller markings at values 5 and 9 indicate the subordinate values.) Figure 14b charts a value limitation extending from value 3 to 7, with the value dominance established at value 7. Any curtailment of the complete value range constitutes a limitation of value, and it functions in the interest of order. Figure 14c shows the value range unlimited, since it includes the value extremes, white and black.

Naturally, the imposition of this restriction must never be so severe as to make impossible the identification of opposing value groups.

BALANCE OF VALUE

The principle of balance is concerned with the provision for opposing groups in all of the visual elements. Its function in relation to value is to ensure that certain values, at some distance on the value scale from the dominant value group, are provided for the sake of relief, or opposition, to the value dominance.

When the value dominance lies between the lightest and darkest values for a given unit, both groups of opposition values together share the role of value balance and their combined areas must remain subordinate to the areas of the value dominance.

DOMINANCE OF VALUE

The principle of dominance demands that the conflict between opposing groups be resolved in favor of one or the other of the opposing groups. Dominance is always achieved through the allotment of the major portion of the total area of the unit to the chosen group. The relative amounts of the total area assigned to the dominant and subordinate groups are discussed further in Chapter 9.

In charting (refer again to Figure 14), the dominant value is indicated by the large ellipse and the smaller markings indicate the subordinate values. When several closely related values establish the value dominance, it is desirable to taper the amounts as shown in the markings within the dominant ellipse. In effect, the taper emphasizes one member of the group.

LIMITATION OF CHROMA

The range of chroma, as charted on the hue circle, extends from neutrality, or the zero chroma, at the center of the circle to the highest chroma charted at the periphery of the circle. Thus, the chroma range is charted on any radius of the hue circle. Any curtailment of the range of chroma constitutes a limitation of chroma, but normally it means a curtailment at the outer end of the chroma range.

BALANCE OF CHROMA

The principle of balance in respect to chroma demands the presentation of opposing groups of chromas. The color areas

which provide the relief to the dominant chroma are known as the areas of *chroma balance*. As in the case of the subordinate values, which may lie on either side of the dominant value group, subordinate chromas may lie on either side or on both sides of the dominant chroma. In the latter case, of course, the outlying opposition groups share the subordinate role, and their combined areas must still be subordinate to the dominance.

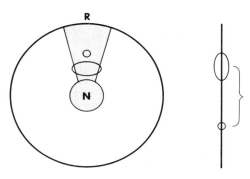

Figure 15

DOMINANCE OF CHROMA

Through the principle of dominance we resolve the conflict between opposing chroma groups. Chroma dominance is achieved when we allot the major portion of the total area of the unit to the chosen chroma group. Dominance may be established upon a single degree of chroma or upon a group of closely related degrees of chroma.

Except in schemes with a severely limited hue range, colorists through the ages have consistently shunned the high-chroma dominance because, as we shall discover, technical difficulties frequently make such an attempt difficult, if not impossible, of solution.

Figure 15 charts a complete scheme in which the chroma range is limited, the highest chroma in the scheme being about middle chroma. Consistent with the lesser contrast of the chroma, the value range is likewise limited.

The Broader View of the Designer's Problem; The Organization of the Noncolor Elements

This chapter directs our attention to certain visual factors which inevitably accompany the color forces in design. To discover what these noncolor elements are, we have only to observe a single spot of color. The color spot will reveal its certain *hue, value,* and *chroma,* but it will also have a certain extension of area, or *mass,* and a certain *shape. Line* will be implied in its contours and directions, and its surface will have the *texture* of the paint itself.

The designer, therefore, must eventually consider the total complex of qualities in the form which he creates. The qualities italicized in the foregoing paragraph are indeed elemental to the form created by the designer.

THE ELEMENTS OF FORM

A minimal category of the elemental aspects of form which enter into the final solution of the designer's problem must include the following:

Line—characterized by its linear existence and by its directional thrust, either expressed or implied

Shape—characterized by the quality of silhouette, for example, curvilinear, rectilinear, angular, or amorphous

Mass—characterized by extent of area, amount, size, space, or volume

Texture—characterized by tactile quality of surface, its roughness or smoothness, either actual or apparent

Hue—characterized by its distinctive place in the spectrum

Value—characterized by the degree of light reflectance, the degree of lightness or darkness

Chroma—characterized by degree of pigment strength, purity, or intensity, the degree of dullness or brightness

It should be noted that the elements do not exist in isolation, but that they coexist. Each quality may be intellectually abstracted, or thought of, in isolation, yet visually each is forever accompanied by the others. It will be seen, then, that the problem of color becomes but a part of the total problem of form and cannot escape the ultimate burden of accepting the total problem and the coercion of all the elemental aspects of form.

Since each of the elements in a unique and separate visual stimulus, it must meet the same orderly demands in its presentation as those we have already discussed in Chapter 5 in relation to the color elements. The design principles are operative in relation to line, shape, mass, and texture in the same way as with hue, value, and chroma.

The student of design needs first to develop an awareness of all the visual elements and then to learn to impose the requisite order upon each of them as he builds them into his design.

Let us now consider the ways in which the design principles function in relation to the noncolor elements.

THE ORGANIZATION OF LINE

Since the chief characteristic of line is its directional thrust, it will be apparent that a design which embraced lines going in all directions could yield only confusion. Some *limitation* of directional possibilities would seem to be imperative.

Since directional thrust must have its counterthrust, or opposition, we have in these opposing directions the essential *balance* required. While a design may include considerable minor diversity of linear directions, stated or implied, there should be no confusion as to the basic oppositions of linear forces.

The principle of *dominance* will demand that a major direction of line, either stated or implied, become clearly apparent throughout the design and recur with much greater frequency and importance than the oppositional direction or directions.

Line is also importantly involved in the matter of *rhythm*, or continuity, in the expression.

THE ORGANIZATION OF SHAPE

The concept of shape can be expressed either in the contour of areas or in lines which do not bound areas. (A *meander* of a curvilinear line expresses curvilinear shape, and a line with rectangular bendings expresses the rectangular shape.)

The forthright opposition of straight-line shapes with curvilinear shapes is the norm for the shape concept. Random, rambling, or composite shapes tend to confuse the shape concept and generally lead the beginner astray. The shape concept occurs in the background spaces as well as in the more positive shapes of the masses.

It is advisable to keep in mind the essential need of the organization: the clear identification of oppositional qualities of shape, with one kind of shape clearly the dominant—dominant because it appears oftener and/or more importantly.

THE ORGANIZATION OF MASS

The designer's term *mass* refers to the amount or size of an area or volume. It has its reverse aspect, *space*, which also is a quantitative measure. The term *mass-space* might be used here to

cover both concepts. Modern designers recognize the defined, but empty, space as *virtual mass,* which functions in formal organization exactly as mass does.

In two-dimensional design—and this is the way we normally appraise any color scheme, that is, by the impact of color areas upon the retina—we are concerned with the relative sizes of the areas presented. Under the principle of limitation, we should consider the range of difference in the sizes of areas. The eye does not readily adjust to the inclusion of tiny pinpoint areas in the same unit with great extensive masses. Therefore, we need to adjust the sizes of areas for one-focus reading, in effect establishing a limitation upon the range of difference permitted the size of masses.

If all areas are small, or if all areas are large, we have, of course, monotony as far as mass is concerned. What we need is a large mass, either a single area or a complex of areas, which commands the design. This becomes the dominant mass; it establishes dominance by sheer force of its size in relation to the oppositions of smaller masses.

Dominance of mass is one of the more elusive and difficult concepts for the student, especially in the field of two-dimensional design. Unlike such elements as hue, value, chroma, and texture, which are implicitly existent throughout the total area, mass exists only as the designer builds it into his work. The mass concept is concerned with relationships of areal groupings which are read against the total area. The subordinate masses usually must exist as entities in their own right, and therefore they should lie (at least partially) outside the encompassing frame of the dominant mass.

Trouble may arise when the dominant mass is stated in a subordinate hue, value, chroma, or texture. In this situation a certain awkwardness results, since the area of the dominant mass is too great to grant to any subordinate factor. However, if the area of the dominant mass can carry principally the dominant qualities of the other elements, it may include subordinate factors in the amount that the organization of these elements demands.

The concept of *virtual mass*—the empty but defined space which reads as mass—is widely current in the contemporary arts.

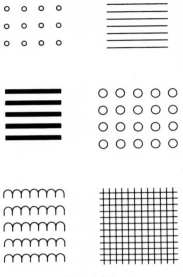

Figure 16

In abstract painting and other two-dimensional design we may find that lines are maneuvered over and across a number of areas to extend and claim territory for the dominant mass.

THE ORGANIZATION OF TEXTURE

This term refers to the surface qualities of roughness or smoothness. It is, of course, expressed in the tactile qualities of actual materials, but apparent textures can be created, as in a printed fabric, or with lines and spots in any two-dimensional design, as indicated in Figure 16.

The principle of limitation functions here as it does with mass. The range of difference in texture must be so adjusted that the eye can accept the difference easily, thus inforcing a limitation in the range of difference in textures admissible to the unit. Texture contrasts should follow the contrast character set for the unit; for example, a unit dealing with bold contrasts will demand a vigorous texture opposition. The principle of dominance, of course, applies here as it does to the color variables. Some degree of texture, or group of related textures, must be made dominant (through area), and the opposition must appear in subordinate amount.

When using a "created" texture, it is usually desirable to build it as a consistent area. A scattering of markings, which does not claim an area as a consistent texture, confuses the textural reading.

In the illustrations which follow we can observe the artists' handling of the visual elements. These paintings, which here lack the hue and chroma of the originals, clearly show the ordered presentation of line, shape, mass, texture, and value.

Figure 17 shows a Chinese silk painting of the Sung period. The artist has created an admirable design with strict economy of means. There are just three major line directions: the balancing diagonals and the stabilizing horizontals. It is the horizontal, however, which gains the dominant position through the stated horizontals in the lower section, the horizontality of the picture itself, and the implied horizontality of the mountain tops. (Turn picture endwise and read as an abstract design.)

The light values are clearly dominant over the opposing darks. The smooth texture (in fact, the texture of the silk) is dominant, while the created texture of the foliage provides the bolder opposition.

The *Seated Woman,* by Picasso, Figure 18, features a rhythmic linear organization. The implied verticality is the dominant direction, which is opposed by subordinate horizontals and diagonals. Curvilinear shapes dominate the canvas and are opposed by straight-line shapes.

The dominant mass is that of the figure itself, opposed by smaller though active masses in the background. The dominant mass is composed of many parts, including many of the opposition features of the design. It is also an example of the use of virtual mass, which allows empty, but defined, areas to read as mass.

The lighter values establish the value dominance, which is opposed by subordinate darks. In keeping with the bold contrast character of the expression, bold created textures oppose the dominant quiet textures. This painting illustrates a number of the technical devices which are discussed in the next chapter.

The *Portrait of a Man,* by Titian, Figure 19, is a fine example of abstract organization within the realist style. The implied

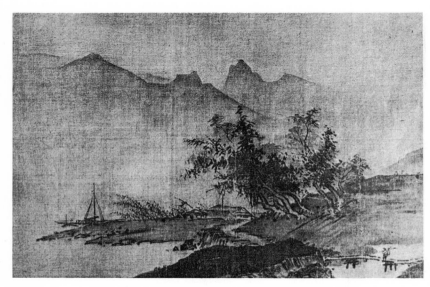

Figure 17. Chinese Silk Painting, Sung Period

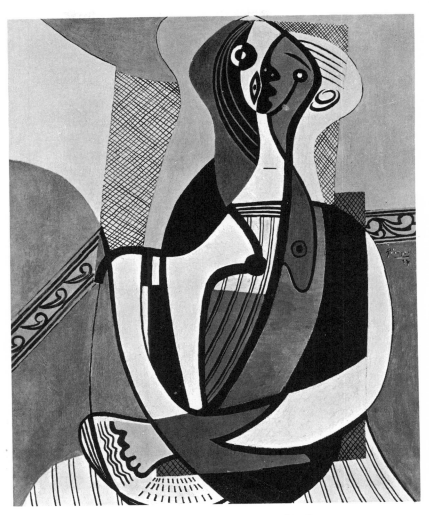

Figure 18. SEATED WOMAN, *by Pablo Picasso*

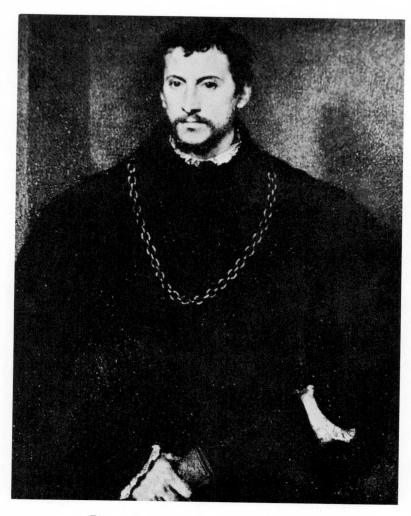

Figure 19. PORTRAIT OF A MAN, *by Titian*

verticality of the figure, aided by the stated verticals in the background, clearly establishes the directional dominance. The vertical dominance is opposed by the implied horizontality across the shoulders and by minor diagonals elsewhere.

The oval shape of the head, restated in the shape of the chain ornament and in the positioning of the arms and hands, establishes the dominance of shape. This curvilinear emphasis is opposed by the straight-line shapes in the background and elsewhere. The dark values are clearly dominant over the subordinate light values.

The mass of the torso establishes the dominant mass, while the lesser masses of head, hands, and background areas provide the effective subordinates. The quieter textures dominate the design, but they are relieved by the texture oppositions provided by the chain, cuffs, and collar.

The Search for Motif;
The Technical Devices
of the Designer

From a study of the preceding illustrations it should be clear that even though an artist works with representational material, he is basically concerned with the organization of the abstract qualities of his forms.

In the present chapter we shall take a first step in the creative handling of these abstract forces of design. We shall work with line, shape, mass, and texture, applying the lessons of theory developed in the preceding chapter. Since these elements always accompany the color factors, we should gain some control of them prior to meeting the larger problem.

One of the best ways to get this experience is to create simple line-and-spot motifs with pencil and paper. The student is advised

to work directly with the abstract elements rather than with representational material, since it is so easy to succumb to the demands of representation at the expense of sound abstract order.

PROJECT 3

OBJECTIVE. To create simple line-and-spot groupings, or motifs, featuring the noncolor elements.

TECHNICAL DIRECTIONS. At first a period of exploration and experiment will be advisable. Discover what visual elements attend your pencil markings. You will, of course, make lines. With lines you can bound areas to achieve masses whose contours will describe shapes. But lines may also be free entities and, if desired, may denote shape without enclosing areas. Textured areas can be created by such devices as parallel lines, rows of spots, or by any repeated markings which will define an area as different from the rest in its quality of apparent roughness or smoothness.

PROCEDURE. After some trials and experimentation, make some purposeful groupings in which you try to sense the need for order. Make conscious effort to avoid haphazard and random markings. Try, rather, to feel what next step in development the design complex needs as it grows to completion.

Follow such trials with groupings in which you bring to bear all of your understanding of design theory. Purposefully limit your statement of each element to clearly opposing factors; then clearly establish the dominances. Think separately about each element. Insist on a dominant-subordinate relationship of each of the four elements which concern us here.

A line-and-spot grouping so produced states the essence of a design idea. Such a statement is called a *motif*—a visual idea expressed in its simplest form. A motif presents a valid organiaztion of each element without elaboration or development. With complete economy of means the motif fulfills the order required for visual unity and becomes the material from which a complete design can develop.

The creation of effective motifs will be considerably facilitated by the knowledge and use of some of the designer's technical devices presently to be discussed. These are simple maneuvers which designers have discovered and invented to increase visual interest and intriguement in a design. A study of these will provide a rich vocabulary of visual effects.

The student should creatively explore these devices with pencil and paper until he understands each one. He should then put them into practice in the creation of motifs.

OVERLAPPING PLANES

This simple maneuver gives visual variation without introducing any new form factor. It is frequently met in combination with other devices such as counterchange, transparency, translucency, and line over mass.

COUNTERCHANGE

This device is based upon overlapping forms, but features a change of value and/or a change of hue and chroma whenever a line is crossed.

LINE OVER MASS

This device dramatizes the difference in mass between a large area and the line which crosses it or is used in association with it. In this illustration the student will observe that all three of the above devices are utilized.

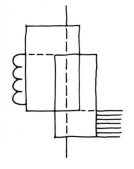

IMPLIED LINE

This is a line which is partially or wholly unexpressed, yet carries the eye nevertheless. Implied lines are here shown in dotted lines which, of course, would *not* appear in the design.

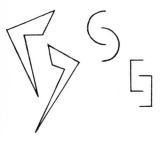

THE INTERLOCK, OR INTERLOCKING RHYTHM

This device, by means of a hooking maneuver, reverses the movement and interlocks one phase of the design with another.

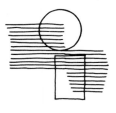
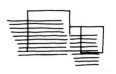

OPEN COLOR

In this device the color masses do not correspond to the contours used. (The term *closed color* is used when the contours of the masses form the color boundaries.)

Offset contour is another expression for open color. Here the designer deliberately shifts outlines so as not to conform to the color masses.

TRANSPARENCY
AND TRANSLUCENCY

Overlapping planes are not al-
ways opaque. The qualities of
transparency and translucency
add notes of visual interest. In the
first drawing a transparent plane
overlaps an opaque one. In the
second, the overlapping plane is
translucent.

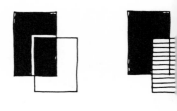

THE FORCED EDGE

This is a device for emphasizing
an important line or edge of a
plane. A gradation of value lead-
ing to the edge strengthens its im-
portance.

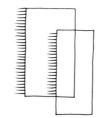

THE DYNAMIC TRELLIS

This device is useful in hand-
ling dynamic linear forces, since
it provides the maximum linear
opposition within an ordered de-
sign. Lines are limited to the fol-
lowing six directions: balancing
diagonals, perpendiculars to each
of these diagonals, and optional
verticals and horizontals.

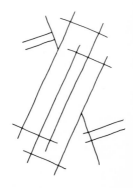

VARIETY WITHIN ORDER

This concept is useful in reminding us that opposition factors in one category need to be tied into the design by alliance with a dominance in another category. In the illustration, curvilinear shapes opposing the dominant rectangular shapes become, nevertheless, a part of, and strengthen, the vertical directional dominance.

An application of this concept to the handling of the color variables will be highly significant as we move further into the color field. Thus, we shall find it important to "protect" a subordinate, or oppositional area, say, in chroma, by making it a part of the hue dominance, the value dominance, or both.

The marginal illustrations which follow are examples of motifs of the kind we have been discussing in this chapter. Analyze each one for its design structure. Can you easily identify the dominant-subordinate relationship for each element? Can you discover the technical devices which are utilized?

Some of these motifs are made within certain strict limitations of line and shape. Line, for example, is limited to the vertical, horizontal, and diagonal. Shapes are rectilinear, triangular, or curvilinear—the curvilinear being the circle or parts thereof, and the curving meander. The resulting forms have the precision and strength of the simple oppositions involved. Such forthright effects

have been utilized in the decorative arts from the earliest times. They appear in the work of primitive peoples and modern designers as well.

The student is urged to explore the potentials of these limitations, and, while not restricting his motif making to these materials, to learn their virtues so that he may, when occasion warrants, have the benefit of their clarity and power.

chapter 9

Motif and Development; The Organization of the Neutrals

In this chapter we shall meet the organizational problems of the simplest of color schemes—the simplest because it will involve but one of the color variables. We shall limit our color resources to white, black, and the grays which their mixture will produce. Such hueless and chromaless colors can be conveniently termed the *neutrals,* and, of course, value will be the only one of the color elements which will be involved. Our problem, therefore, becomes the study of value organization, and our findings will be pertinent to the organization of value in all color schemes.

Before taking up our paints, however, let us consider some important aspects of the problem which will have a bearing upon our success in dealing with the creative projects which follow.

Given only the range of values as provided by the neutrals, the possibilities for different organizations are nevertheless tremendous. We may work within the confines of any limitation of the value range or we may use the value range unlimited and thus include the value extremes, white and black. We may establish

value dominance upon any degree of the value scale or upon any group of closely neighboring values.

In solving a specific color project, an important determinant of the choices detailed in the paragraph above lies in the expressive goal which is deemed appropriate for the particular project. The intended expression is conveyed, as we shall note in more detail in Chapter 13, both through the choices of the dominances and in the degree of contrast chosen for the opposition. Let us here consider the expressive range possible to the contrasts of value.

(a) (b) (c) (d)

Figure 20

TECHNICAL ASPECTS OF VALUE CONTRAST

Figure 20 diagrams four different value schemes. In the first three the value range is unlimited, permitting effects of strong contrast. In (a) the value dominance is white and the opposition value is black. In (b) the dominant-subordinate roles are reversed. The effect in either case is shrill and brilliant. Here we have the stark drama of opposing forces. The effect of violent contrast is increased when the opposition is concentrated in appreciable areas, and it is mitigated somewhat when the opposition is scattered in small areas.

In (c) the dominance has been established between the extremities of the value range, here upon a group of related values center-

ing upon value 7. The effect of strong contrast is maintained by the shock of black against white, yet the starkness has been relieved by the intervening values supplied by the dominant value group. The variety of contrasts which this type of organization permits serves to enliven and enrich the scheme, allowing not only the strong shock of black against white but also the lesser contrasts of white versus the dominance and black versus the dominance. The virtues of this type of value structure will become more apparent as we meet the full color problem in the chapters following.

In (d) the value range is limited. Any curtailment of the value range naturally reduces the force of contrasts possible to the scheme and is the chief technical means for achieving the effects of subdued contrast. But even in schemes of the greatest subtlety, the dominant-subordinate relationship needs to be strictly maintained.

THE ACHIEVEMENT OF DOMINANCE

It is interesting to observe that while line, shape, and mass exist only as the designer chooses to build them into his design, the qualities of color, and of texture, are inherent properties of all areas and coexist throughout the total area of the project. In organizing these elements the total area is involved in the allotment of area to the dominant and subordinate groups.

The technical achievement of dominance requires only that we gain sufficient area to dominate the scheme. But how much is sufficient? Our own emotional responses, should we care to heed them, will prove to be a reliable guide, but the beginner tends to underplay the dominances, leaving the issue in doubt.

The dominant-subordinate relationship cannot be stated in precise mathematical terms; yet we shall not be far wrong if we consider the implications of the so-called golden-mean proportion. This relationship has been consistently verified by human responses since ancient times. It is a relationship of linear measure, however, while the proportion we seek must deal with areas. In the following paragraphs the golden-mean proportion is translated into its areal equivalents.

Figure 21 Figure 22

THE GOLDEN MEAN

We can approximate the golden-mean proportion if we seek to divide any line into pleasing proportions by setting a point B somewhere between the line extremities A and C. If B were placed halfway between A and C, making equal measures, the result would be monotonous and unpleasant. If B were placed too close to A, we would feel the awkward proportion of a pinched AB and a very long BC. Somewhere between this point and the halfway point we may expect to find a place which divides the line into pleasing proportions. Your own emotional responses will tell you when the measures seem just right. Try it.

The ancient Greeks seem to have arrived at this proportion by geometry, Figure 21. A diagonal to half a square is swung in an arc to extend the length of one side of the rectangle. This gives the structure of the golden-mean rectangle whose sides AB and BC are in the desired relationship. If the point C is now swung up to point C′, we can appraise the measures on a straight line. (Compare these measures with your intuitively chosen measures.)

But since, in color relationships, we are concerned with area rather than with linear measure, it is pertinent to observe the translation of the golden-mean measures into areas.

If we erect one square on AB and another on BC′, we can appraise the relationship of *areas* which are based upon the golden-mean proportion, Figure 22. The relationship of the large square to the small one suggests the relationship between dominance and subordinance. To estimate the proportion of the subordinate area to the total area of the unit, we should, of course, add the two

squares together and then observe the relationship of the smaller square to the total area. It will be found to approximate roughly 20 to 25 per cent of the total area.

Such an observation, however, should be taken only as a general guide, since the nature of a particular design, its contrast character and expressive intent, will qualify the amount of the opposition demanded. The extent to which the subordinate factor is concentrated in larger pieces or scattered in smaller areas will also influence the amount required. (More total area of the opposition can be accepted by the unit if it is scattered in small pieces.) Experience will show that the amount of the subordinate may also vary for the different qualities of color. Thus, the amount of the subordinate chroma may need to be considerably less than that required for the subordinate value or the subordinate hue.

We must rely finally upon our sensitivity to these relationships. In any design well-established dominances are essential. We need only to keep building dominances until by sheer force of area they proclaim themselves. The handling of the oppositions, however, as mentioned earlier, involves considerable understanding and technical knowledge.

SPECIAL HANDLING FOR THE SUBORDINATE AREAS

For the present let us consider just three points which are pertinent to the handling of not only value oppositions but of all subordinate areas. These concern the *amount, placement,* and *distribution* of the subordinate factors.

Amount

The foregoing discussion on the achievement of dominance should give us some basis for regulating the amount of area to be assigned to the subordinate factors. Any great departure from the norm indicated in the golden-mean relationship should be scrutinized closely. We may unwittingly assign too much area to the opposition, in which case the dominance is jeopardized. But we may err in the direction of too little area for the subordinate and so spoil the drama of the opposition which we know is an imperative of the art form.

Placement

Since the oppositional features of a design serve as relief or change from a dominance, they must be placed where the greatest need of them is felt.

This usually means that they should be dropped in at the heart of the design rather than at the periphery or in the corners. It is better to feel that the dominances are commanding the broad extent of the unit while the subordinates play their parts within. This is not to say that a subordinate area may not touch the outer border of the design, but that if it does, there should usually be recurrences of it at the heart of the design.

Distribution

To achieve a sense of consistency in the contrast character, it is usually necessary to have the opposition recur in several places over the surface of the design. In a certain type of symmetrical design, however, it may be possible to have a single statement of the subordinate somewhere in the central axis of the symmetry. This should be regarded as an exception, since normally a distribution is desirable.

Building upon our experiences in the last chapter, where we created motifs stressing the order of the noncolor elements, let us now proceed with the creation of motifs which will add the value potentials to those of line, shape, mass, and texture.

PROJECT 4

OBJECTIVE. To create valid visual motifs with special attention to the exploitation of the potentials of value.

TECHNICAL DIRECTIONS. Premix values light, middle, and dark which with white and black will provide a skeleton value scale from which any desired value may be quickly produced. Work with paint and brush upon white drawing paper or cardboard. Small file cards, 3 by 5 inches, are about right for this exercise.

PROCEDURE. Before starting a motif, predetermine the character of the contrasts you propose to maintain. You might also decide upon the value dominance. It is not, however, advisable to start with a fixed line-and-shape motif, since there is no way to predetermine the precise areas your value scheme may require. Any penciling of your intentions should be very tenta-

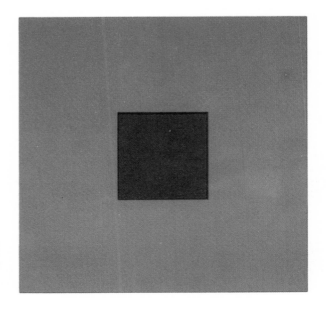

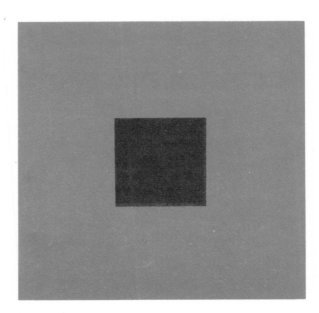

Figure 2

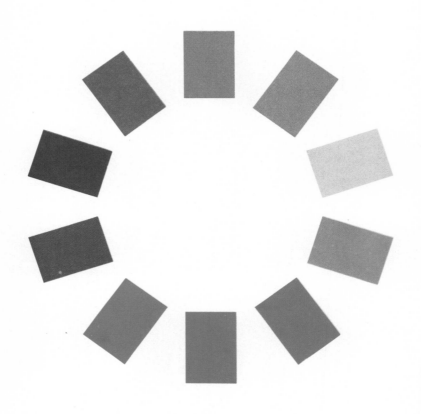

THE HUE CIRCLE, *by Munsell*

60

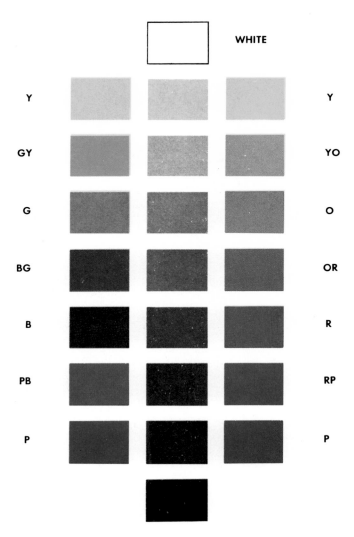

Figure 9. Scale of Spectrum Values

level beside a value scale. (This we shall do in Project 1.) As shown in Figure 9, there will be two sequences, one running clockwise and the other counterclockwise from Y to P around the pigment circle.

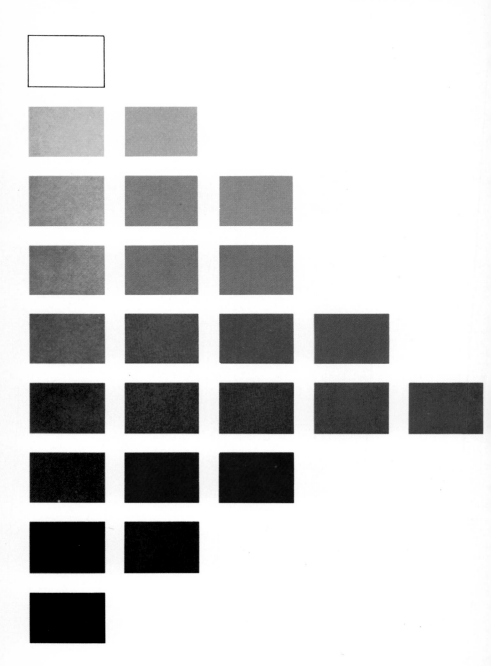

Figure 10. Constant-Hue Chart for Red

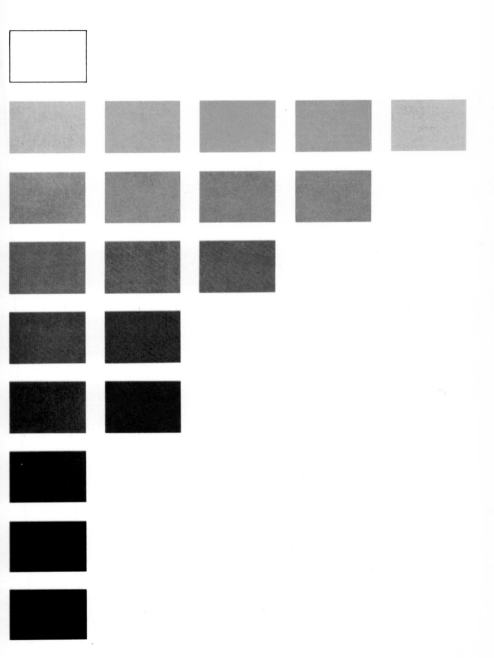

Figure 11. Constant-Hue Chart for Yellow

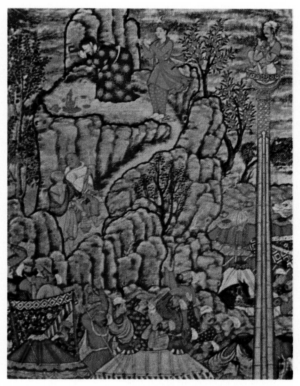

INDIAN MINIATURE PAINTING, *XVI Century*

*The structure of this fine color scheme is clear and
straightforward. It should be a good one to start with.
Note first that there are warm hues and cool hues, and that
the warm hues are dominant by reason of their greater
area. In the same manner the lighter values are dominant
over the extreme lights and darks. Most of the total area
is given to the low chromas, and the opposition occurs in
the brighter areas of high chroma.*

THE SINGLE HUE AND NEUTRAL SCHEME WITH NEUTRALS
DOMINANT, *by Gene Carara*

*In this striking solution to Project 7, bold contrasts are
consistently maintained in all three of the color variables.
The hueless neutrals state the hue dominance, and an
orange-red supplies the balance of hue in subordinate area.
Values 7 and 8 establish the dominance of the lighter
values, and white, black, and below-middle values provide
the opposition. The neutrals, stating the zero of chroma,
establish the chroma dominance, which is opposed by the
high chroma of the orange-red.*

*The bright orange-red areas are subordinate in both
hue and chroma yet are a part of the value dominance.
The alliance with the value dominance is important, since
it is the only way these areas can relate to the scheme.*

THE SINGLE HUE AND NEUTRAL SCHEME WITH THE
SINGLE HUE DOMINANT, *by Gene Carara*

This is a solution to Project 9. With the hue dominance carried by the warm red, the neutrals now provide the hue balance. The gray areas, opposing both the hue dominance and the chroma dominance, ally with the value dominance.

THE ADJACENT HUES AND NEUTRAL SCHEME,
by Don Beehler

This is a solution to Project 10. The hue dominance is carried by the adjacent hues, while neutrals provide the balance of hue. The gray relates to the value dominance and reads warm against the cool hue dominance.

Blue-green, the central member of the dominant hue group, is emphasized (through area) and easily carries the subordinate (high) chroma for the unit, as well as some spread in value.

THREE MUSICIANS, *1921 (summer), oil on canvas, 6'7" x 7'3¾", by Pablo Picasso. Collection, The Museum of Modern Art, New York. Mrs. Simon Guggenheim Fund.*

In this design of bold contrasts the artist presents a tightly organized color structure. The hue range is limited to the split complement. The dominances are securely established. Warm hues are dominant over the opposing blue. Middle values are dominant, opposed by extreme lights and darks. Low chromas are dominant, opposed by high chroma carried by both the orange-red and the blue.

Unusual is the bold handling of the blue areas, which are subordinate in both hue and chroma. Since the orange-red also carries the bright shock of chroma, the tensional opposition of these colors is extreme. Both of these subordinate chroma areas, however, ally with the value dominance. (The orange-red relates to the hue dominance as well.)

In the field of contemporary painting such purposeful heightening of the emotional tensions is frequently dictated by the artist's expressive goal.

68

DiDi Playing the Guitar, *oil on canvas, 24″ x 34″,*
by the Author

The color scheme is a split complement with dominances
of warm hues, middle to dark values, and low chromas.
The subordinate areas of hue, value, and chroma all relate
to two dominances.

Consistently bold contrasts are maintained in the massed
oppositions of warm hues against cool, dark values against
light, and dull chromas against bright.

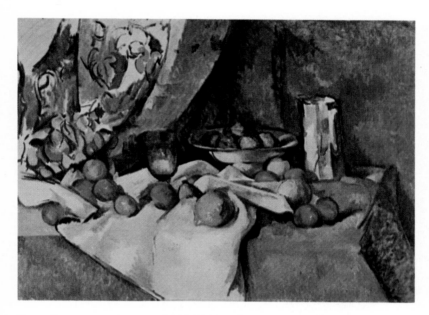

STILL LIFE WITH APPLES, *1890-1900, oil on canvas, 27" x 36½", by Paul Cézanne. Collection, The Museum of Modern Art, New York. Lillie P. Bliss Collection.*

In this beautiful painting the artist adds zest to the split-complement scheme by the addition of green-yellow and purple discords. The warm hues are dominant, and cool hues provide the subordinate opposition. Value dominance is established upon the lighter values (6 to 8), while the extreme lights and darks provide the opposition. The dominant low chroma is opposed by the bright shocks of high chroma.

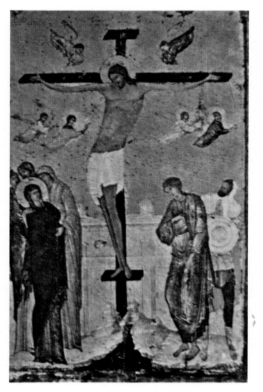

THE CRUCIFIXION, *a Russian Ikon of the XV Century*

The fine color structure of this painting is based upon secure dominances of hue, value, and chroma. The subordinate chroma (the bright orange-red) is allied with both the hue dominance and the value dominance. The greens and blue-greens provide the effective hue balance and relate to the chroma dominance.

The green-yellow and purple are essentially out-of-scheme hues, yet because of their low chroma they do not function as discords. They serve to add hue variety, and because of their interim position may be read either as assisting the hue dominance or opposing it.

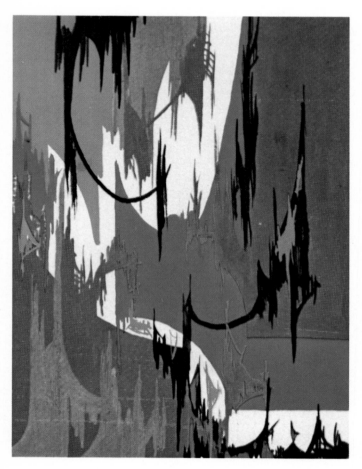

THE TRIAD SCHEME, *by E. L. Isaacson*

This bold and vital solution to Project 18 features a high chroma dominance. The success of the scheme rests upon a choice of a triad whose hues at high chroma are nearly the same in value. The subordinate hue areas thus relate to both the value and the chroma dominances.

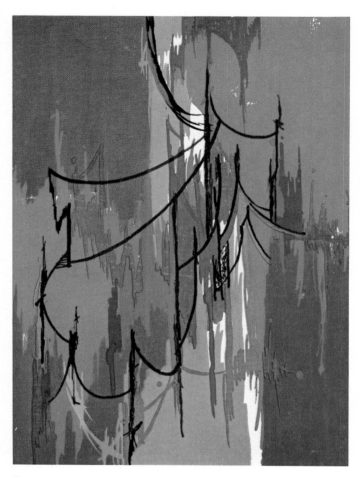

THREE HUES AND THEIR COMPLEMENTS, *by E. L. Isaacson*

This lively color scheme is a solution to Project 22. Bold contrasts of hue, value, and chroma are consistently maintained.

The warm hues establish the hue dominance and are opposed by their complements in subordinate area. The middle-value group (rather widely extended) establishes the value dominance against which the extreme lights and darks provide the bolder value contrasts. The middle chromas are dominant and are opposed by the high chroma seen in the bright-red areas and by the zero chroma of the neutrals.

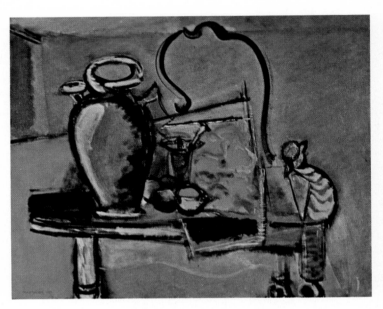

MEXICAN JUG, *1951, oil on canvas, 25" x 30", by Max Weber, American Painter, XX Century*

This strong and vital expression features secure dominances of warm hues, light values, and low chromas, against which the oppositions make consistently bold and sharp contrasts. Unusual is the concentration of the extreme contrasts of all color elements at the center of the canvas where they serve the expressive purpose of heightening the emotional tensions.

The bold statement of the opposition hue deserves attention since it is a departure from harmonic usage. This area is indeed opposed to all three of the color dominances, and so contributes to tensional stress. Necessarily it is restricted in size. Elsewhere the hue opposition appears in the widely distributed areas of cool grays and dull blues which relate to both the value and the chroma dominances.

The student of color should recognize that the goals of expressionist painting will not serve all his purposes; nor will the goals of decorative usage. It will be rewarding to compare the handling of the subordinate hue in the INDIAN MINIATURE, *the* THREE MUSICIANS *by Picasso, and the present illustration.*

tive so that you may easily adjust to the design need as your motif grows to completion.

Let your feelings about your paint spots guide you. Imaginatively sense possibilities as you respond directly to the design forces on your paper. Try to put into practice what you have learned about the art form and design unity. Stop when an idea seems complete. Then try another.

Make some motifs using bold contrasts and others with subtle contrasts. Make some motifs with light values dominant and others with dark and middle values dominant. Clearly identify the dominant value group (either a single value or a group of closely related values) by giving it the major portion of the total area. Let the opposition values clearly read as contrasts to the dominance and keep them subordinate in area. Drop them in precisely where you feel they are needed. Adjust your design to accommodate them.

Finally, evaluate and revise your motifs. Drastically eliminate, or minimize, all features which neither strengthen the dominances nor directly oppose them.

The marginal illustrations shown here should give you a good idea of the motif concept. The discipline involved in creating a motif is important experience for the student because it forces him to think about the essential order upon which visual unity depends.

DEVELOPMENT OF MOTIF: DESIGN TO A FIXED AREA

Although a motif presents the essential visual material of a design idea, it is only through the development and interplay of its form factors that the complete design structure is achieved. A motif serves the designer as a motivating spark and a guiding star. It is an orderly frame of limited materials within which he may work freely and creatively.

For the experienced designer motif may not need to be completely formulated. It may be only a nebulous and haunting fragment of an intriguing visual idea which provides a sufficient springboard to his creative venture. In that case motif finds its completion, along with its development, in the growing structure of the design directed by the designer's sensitive emotional responses and his regard for the art form. For design students it will usually be advisable to have well-formulated motifs in hand before embarking upon the developmental phase.

A design is planned and developed in relation to the area fixed by the project, be it a poster, painting, stage setting, costume, or whatever. Thus, it is the total area of the project, embraced and commanded by the interplay of the design forces, which must present a visual unity. We must learn, therefore, to so manipulate the materials of a motif that they may encompass and command the total area of a project.

PROJECT 5. DESIGN TO A FIXED AREA

OBJECTIVE. To develop a complete design, within a fixed area, based upon a motif in strong contrasts created in Project 4.

TECHNICAL DIRECTIONS. In order to gain the experience of developing the complete visual unit, establish a fixed area, say a rectangle of 5 by 7 inches, which will represent the total area of the proposed project. Select the most promising of your motifs that feature bold contrasts. Work freely within the frame of the limitations, dominances, and balances indicated in your motif. Do not simply reproduce the motif.

PROCEDURE. Think of the total area as the field which must be encompassed by your design. From your motif read and follow the design order as indicated; yet within the strict frame of such order, freely and imaginatively manipulate the elements as may be necessary to encompass the total area.

A mental grasp of the limitations, dominances, and balances indicated in the motif will help you in developing your design toward the goal of visual unity.

PROJECT 6.
DESIGN TO A FIXED AREA

OBJECTIVE. To develop a complete design, within a fixed area, upon a motif in subdued contrasts created in Project 4.

TECHNICAL DIRECTIONS. As in Project 5.

PROCEDURE. As in Project 5.

The accompanying illustrations are of completed designs based upon motifs shown earlier in this chapter. One features bold contrasts; the other, subdued contrasts. Note the ordered presentation of each of the five elements involved, the clear statement of the dominances and their oppositions. Observe the handling of the subordinate areas and the use of some of the technical devices.

The Single Hue and Neutral Scheme with the Neutrals Dominant

Figure 23

The next step in our exploration of the field of color will be to add a single hue to the neutrals we have been working with. This extension of the hue range, an example of which is diagramed in Figure 23, adds the dimensions of hue and chroma to our problem. Our new task will be to supply the appropriate color areas which will carry the subordinate hue and chroma.

Visualize the scheme as diagramed. Neutral grays stating the value dominance around middle value, with flashing black and white value oppositions, set the main features of the value structure. Against the neutral (hueless) dominance of hue, a single hue, R, plays its oppositional role in subordinate area. Neutrals, stating the zero degree of chroma, establish the chroma dominance, while the subordinate chroma appears at the highest chroma in the bright red of the subordinate hue area.

The variations of this scheme are widely used because of the simplicity and beauty which can be readily achieved. It is, of course, the simplest of the color schemes which involve all three of the color variables.

In undertaking the creative solution to this problem, it is suggested that the student convert the two neutral schemes he has worked out in Projects 5 and 6, Chapter 9, to the present scheme by the simple addition of small color areas representing the subordinate hue and chroma.

However, lest we think that one color spot will do as well as another, let us consider certain organizational demands which will in some measure limit our freedom of choice, if not directly dictate the acceptable color qualities.

A DIRECTIVE FOR CHROMA

Since the character of the contrast plays an important role in the expressive communication of the color unit, it is normally desirable to maintain the expression consistently throughout the unit. Thus, if our unit is geared to bold contrasts in value, it will normally welcome, if not demand, bold contrasts in chroma. If it features subdued value contrasts, it will require subdued contrasts in chroma. Otherwise, we would endanger the clarity of the expressive meaning.

A DIRECTIVE FOR VALUE

One of the most troublesome features of color organization will be met for the first time in this problem. It concerns the necessity for establishing the relationship of every color area to the whole

unit. In Chapter 8, in the section Variety within Order, we observed that an opposition factor in one element can best be handled by relating it to a dominance of another element. The subordinate shape, for example, might establish relationship with the unit by becoming a part of the linear dominance.

Because of the mutually close association of the three color elements, which together form the color experience for us, a subordinate in any one of them needs alliance with at least one of the color dominances. An area which is opposed to all three dominances will refuse to become part of the unit. It will appear isolated and unrelated to the rest of the scheme.

In the present problem the subordinate hue area carries the subordinate chroma as well. In other words, this color area is already opposed to two dominances. The one possible alliance is with the value dominance. Therefore, the value of your added color spots needs to be close to that of the value dominance.

A DIRECTIVE FOR HUE

Nor are we completely free agents in our choice of hue. This becomes pertinent only in the schemes of strong contrasts. Since high chroma will be demanded as a strong chroma contrast against the dominant (zero-chroma) neutrals and since the value of this area must ally with the value of the value dominance, we shall find that our choice of hue will be limited to those hues which can provide high chroma at the required value level. If, now, we consult the scale of spectrum values, Figure 9, we shall see which hues can provide the high chroma at or near the value we desire.

In the scheme diagramed in Figure 23, red was selected because it was one of the hues which could provide high chroma at a value close to the value dominance. In a color scheme which does not demand high chroma we retain freedom of hue choice, since any hue can provide the lower chromas at a variety of value levels.

The foregoing concepts, listed as directives for chroma, value, and hue, have continuing validity throughout our study. It is important to gain a clear understanding of them as they relate to the present problem.

PROJECT 7

OBJECTIVE. To create a color scheme in the single hue and neutral limitation, with the neutrals dominant over the single hue, and featuring bold contrasts.

TECHNICAL DIRECTIONS. Since the neutrals establish the hue dominance (huelessness), they automatically establish the chroma dominance (the zero of chroma) as well. Since the contrast character of the unit is to be one of strong contrasts, the value and chroma contrasts will need to be vigorous. At this point in your preview of the situation you have the option of 1) choosing the value dominance which in turn will, to a degree, dictate the choice of the single hue or 2) choosing the single hue which, according to its spectrum value, will dictate the value dominance.

PROCEDURE. Option 1. With a given value dominance, that shown in your Project 5, for example, the choice of the single hue must be one which can achieve a high chroma at the value level of the value dominance. (See Scale of Spectrum Values, Chapter 4.) The simple addition of subordinate hue and chroma areas to the neutral scheme created for Project 5 will achieve the solution desired.

Option 2. If we are committed to a certain hue, or choose one at random, our hue choice will dictate the value dominance required for the unit. The reason, of course, lies in the technical necessity of establishing a protective alliance for the areas of subordinate hue and chroma.

PROJECT 8

OBJECTIVE. To create a color scheme in the single hue and neutral limitation with the neutrals dominant and featuring subdued contrasts.

TECHNICAL DIRECTIONS. Since the expressive goal of the scheme is one of subtlety and delicacy, subdued contrasts of both value and chroma are indicated. The subordinate areas of hue and chroma must ally in value with the chosen value dominance, but freedom of choice of hue is possible since every hue has considerable value potential at the lower chroma levels.

PROCEDURE. Option 1. Start with the completed neutral scheme (subdued contrast) created for Project 6. Produce your choice of hue at the level of the value dominance and in a degree of chroma which will be consistent with the contrast character already established by the value contrasts. Set this color into your neutral scheme. Be prepared to revise your design slightly to accommodate the new areas, since you must remain in control of the amount, placement, and distribution of your subordinate areas of hue and chroma.

Option 2. Determine the degree of contrasts in both value and chroma; consistent contrast in both is desirable. Determine the value dominance, which will in turn determine the value of the subordinate hue and chroma

areas. Make your choice of hue and produce it at the required degree of value and chroma. The color so produced will provide the areas of subordinate hue and chroma which will ally in value with the value dominance. Check for amount, placement, and distribution of all subordinate areas.

ANALYSIS AND EVALUATION

When you have completed a project, label it according to its type of scheme and chart the color organization on the circle-and-staff diagram as shown in Figure 23. It will be helpful also to make a written analysis of the organization, thus to observe the functioning of the principles of limitation, dominance, and balance in relation to each of the color variables.

The written analysis of the scheme charted in Figure 23 would be as follows:

The organization of hue. Hue range limited to a single hue and neutral. Hue dominance: established upon the neutrals. Hue balance: the relief offered by the hue red.

The organization of value. Value range is unlimited (it includes black and white). Value dominance: established upon a group of related values around middle value. Value balance: subordinate areas of the extremes of value.

The organization of chroma. Chroma range unlimited (since it includes the extremes of chroma). Chroma dominance: established upon the neutral or zero end of the chroma scale. Chroma balance: subordinate amount of high chroma.

A gridiron such as that shown below provides a quick and systematic way to record the analysis of a color scheme.

	Limitation	Dominance	Balance
Hue			
Value			
Chroma			

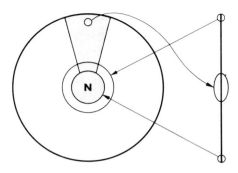

Figure 24

THE USE OF ARROWS IN CHARTING

The circle-and-staff diagram can be made even more effective by the use of the arrow to indicate the protective alliance of a subordinate factor with a dominance. Figure 24 shows arrows added to the diagram shown in Figure 23.

Through the use of the arrows we have the means of recording the complete color description of all subordinate color areas. For the sake of clarity the arrows should run from the subordinates and point to the dominances with which they ally.

chapter 11

The Single Hue and
Neutral Scheme with the
Single Hue Dominant

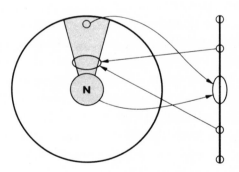

Figure 25

In this scheme we have the same hue limitation as in that dis-
cussed in the preceding chapter, but now the hue dominance is
placed upon the single hue and the neutral provides the hue bal-
ance, or opposition.

Figure 25 charts an example of this type of organization.
Notice how the arrows (discussed at the end of the preceding

chapter) provide for the complete description of the color areas which carry the subordinate or oppositional factors of the organization. For example, the subordinate chroma (high-chroma) area is part of the hue dominance and part of the value dominance, as indicated by the arrow. The subordinate values are stated in the hue of the hue dominance and in the chroma of the chroma dominance, as indicated by the arrows. It is usually desirable to state the ranges of value and chroma for the unit in the areas of the hue dominance, although when the extreme value contrasts are needed, black and/or white are welcome additions. The black and white, however, naturally cannot relate to any of the color dominances. In this respect they are exceptions to the principle of "protection" for subordinate areas. But such immunity is not readily granted to the other neutrals. The welcome grays are those which relate to—and are, therefore, part of—the value dominance.

Before attempting to create a color scheme in this limitation let us look first at the resources of the hue we have chosen as the dominant hue.

We must renew our acquaintance with the constant-hue chart, the triangular diagram which charts the value and chroma potentials of a given hue. The important feature of the triangular chart is the placement of the outer point of the triangle at the value level (spectrum value) at which a particular hue may attain its greatest chroma strength, Figures 9 to 11.

To know the spectrum value of a given hue becomes pertinent in schemes of strong contrast, since the high chroma, usually a subordinate factor in the scheme, needs to ally with the value dominance as well as with the hue dominance if complete protection is to be granted this opposition factor. Thus the value dominance should be established at or near the level of the spectrum value of your chosen hue.

In schemes of lesser contrast, which do not demand the full shock of chroma, the value dominance need not be restricted to the spectrum-value level; yet the subordinate chroma area, at whatever value, needs the support of an alliance with a value dominance placed at or near its own value.

TECHNICAL DIFFICULTIES WITH HIGH-CHROMA DOMINANCE

It might seem that a unit of strong contrast would demand a high-chroma dominance. Indeed, the ultimate shock of contrast could be so delivered, yet the technical organization of such a scheme becomes fraught with difficulties and impossibilities in all but the very limited hue schemes.

Strong contrast of chroma is attainable with more flexibility if the dominance is given to the lower chromas and the shock of contrast is administered in subordinate area of high chroma.

Let us take the case of high-chroma dominance in the present scheme, a single hue and neutral, with the hue dominant. Suppose we take the hue red. To ensure a high-chroma dominance, most of the total area would have to be bright red. Automatically this would establish the value dominance as well, at value 4. Value oppositions would have to be carried by the neutrals because areas of lighter or darker reds would be too weak in chroma to hold their places in this scheme of harsh contrasts. The only neutrals for this purpose would be the white and black. A gray at the value of the value dominance, however, would be welcome as the hue relief, but neutral grays at the other values would seem out of place, since they would be opposed to all three of the color dominances and would not have the immunity permitted to white and black. Such a scheme, diagramed in Figure 26a, is certainly a possibility and is aesthetically valid when appropriate to the project in hand; yet it is by nature harsh, strident, and brilliant, and its uses are accordingly limited.

When more hues are involved in a high-chroma dominance, the technical difficulties become prodigious, especially when complementary hues are involved.

Figure 26b diagrams the technical situation when the chroma dominance is established upon the low chromas and the value dominance is at the level of the spectrum value of the chosen hue. Now the high-chroma opposition exerts its impact against the low-chroma dominance, but it is fully protected by its alliance with both the value dominance and the hue dominance. Within the areas of the low-chroma dominance a spread of value is possible,

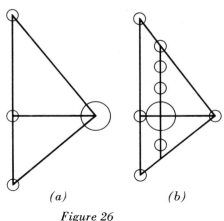

(a) *(b)*

Figure 26

thus allowing subordinate values to ally with the chroma domi-
nance as well as with the hue dominance. The neutral gray at the
spectrum value of the dominant hue becomes the hue opposition,
protected by its alliance with the value dominance. White and
black would also be welcome for increased value contrast.

If color is so planned that the subordinate areas relate to *two*
dominances, the utmost order is achieved and complete acceptance
of every color area is assured. A unity of color, however, is still
possible when the subordinate factors relate to but a single domi-
nance; but the double alliance must be regarded as the ultimate
perfection in color order, and any departure from it should be
purposefully considered.

SIMULTANEOUS CONTRAST

In this scheme the neutral areas serve as the hue balance, and
the effect of simultaneous contrast will be noticeable. The gray
areas will take on the appearance of the complementary hue in low
chroma. In our charting, however, we should ignore this effect
and chart the neutrals as neutral.

CORRECTION FOR TRUE NEUTRALS

The grays that will be produced by a simple mixture of white
and black will not be strictly neutral because of a bluish cast in
the black pigment (ivory black). See Chapter 4, Project 2, for a

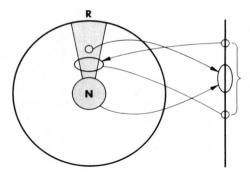

Figure 27

discussion of this point. It will be advisable to correct the grays toward strict neutrality by adding to the mixture a touch of orange pigment.

THE SCHEME IN SUBDUED CONTRASTS

Figure 27 charts a scheme in subdued contrasts. In this situation the highest chroma is not utilized, and the value dominance may be established elsewhere than at the spectrum value of the hue.

PROJECT 9

OBJECTIVE. To create a color scheme in the single hue and neutral scheme with the single hue dominant.

TECHNICAL DIRECTIONS. Consider the potentials of the hue of your choice. This means knowing the configuration of the constant-hue chart for this hue. If you plan on a scheme of strong contrasts, it is important to know the spectrum value of this hue, the value at which the highest chroma may be found. This knowledge has a bearing upon your choice of value dominance. As to chroma dominance, the discussion earlier in this chapter indicated technical reasons which usually favor the choice of the lower chromas for dominance.

PROCEDURE. Having determined the contrast character for the unit and having foreknowledge of the dominances you intend to establish, you have set a frame within the limits of which you may work creatively and freely.

Although you have set certain structural goals for your design and possess the technical means for achieving them, the creative endeavor still requires your personal responses to the intimate relationships of the growing design. Working within a frame of structural goals is precisely the situation in which you can freely exercise your emotional directives.

You must consult your feelings about the qualities of form you are bringing together in intimate association. Such responses are intuitive and require only that you act upon them. A first requirement is an awareness that you do have a personal contribution to make and that your feelings are of primary importance to the success of your efforts.

If you can preestablish certain goals in the ordering of line, shape, and mass, you can work purposefully from the beginning of your creative attempt and avoid time-consuming trial-and-error maneuvers. It is not recommended, however, that the line-and-shape motifs be drawn in as a first step, since there is no way to predetermine the areas needed to accommodate the organization of the color variables. But the concept of motif—the essential nature of the line-and-shape goals (dominances and balances)—can be kept in mind as the design grows.

Develop your design within a fixed area, say, a rectangle of 5 by 7 inches, drawn upon a sheet of 9- by 12-inch drawing paper. This will give you a space at the bottom for the title, circle-and-staff analysis, and perhaps the gridiron analysis as well.

Evaluate your design when it is completed. Check the design order of each element. See that the dominances proclaim themselves clearly over their oppositions. Check the subordinate areas as to amount, placement, and distribution. Check for consistent handling of the contrast character. When an error is spotted, make the correction at once.

In the series of projects presented in the course of this study let your goal be the achievement of original color designs which are as valid and perfect—in short, as beautiful—as you can make them. In this striving for perfection you will develop a great sensitivity to visual relationships and gain technical control of your expression.

The Adjacent Hues and Neutral; Rhythm in Color

In the adjacent hues and neutral scheme, we extend the hue range to include several neighboring hues opposed by the neutrals. This scheme has the virtue of presenting considerable diversity of hue while actually exploiting but a limited sector of the hue field. With the adjacent hues dominant, the neutral opposition assumes the appearance of the hue which is complementary to the dominance (through the operation of the phenomenon of simultaneous contrast, Chapter 2), and so the apparent hue variety surpasses the actual variety.

This feature of the scheme has made it a favorite with painters through the ages. It is found frequently in the work of Titian, Rembrandt, De Hoogue, Hals, Daumier, and Modigliani, to name but a few.

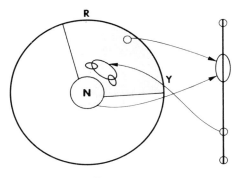

Figure 28

Figure 28 charts such a scheme. It is a scheme of strong contrasts, as indicated in the unlimited ranges of value and chroma. The adjacent hues establish a common hue dominance which is opposed by the hueless neutrals. The lower chromas are dominant, opposed by the high chroma. (The neutrals, representing the zero of chroma, must also be considered as part of the chroma opposition.) The value dominance is established upon a group of closely related values centering around value 6. The value dominance affords a protective alliance for the subordinate chroma area, and also for the subordinate hue area (gray), both of which state values similar to the value dominance and are therefore actually a part of the value dominance. The arrows on the diagram graphically show these alliances. A third arrow indicates that a subordinate-value area states the hue of the hue dominance and the chroma of the chroma dominance.

ALLIANCE OF ADJACENT HUES IN A COMMON DOMINANCE

When, as in the scheme diagramed, the hue dominance is established upon the adjacent hues, we must take precautions to ensure a common alliance of these hues against the neutral opposition. We are, therefore, limited in the number of hues we may hope to unite in a common dominance. Three neighboring hues can be easily managed. With care and know-how we might extend our range to four or five. Beyond this it is impracticable to go, since the problem of the disparity of the outside hues becomes insurmountable.

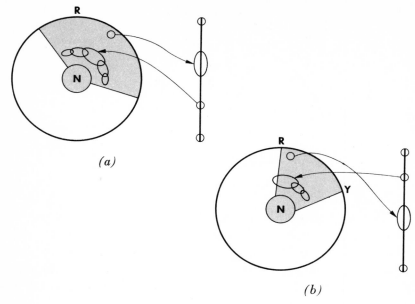

(a)

(b)

Figure 29

In every case it is advisable to stress some one sector of the
hue spread by giving it greater representation. (It is also advisable
to avoid gaps in the hue sequence in order to minimize the danger
of a split within the dominant alliance.)

In the scheme diagramed in Figure 28, the emphasis is placed
upon the central hue YR, while lesser area is granted the outlying
hues. If a greater spread of hues were to be included in the hue
dominance, the amounts should continue to taper as we leave the
point of emphasis.

In Figure 29a, five hues have been included in the common
hue dominance, with the emphasis in the central part of the hue
spread. As a further precaution, the outside hues should play into
their immediate neighbors and never against each other, lest a hue
antagonism jeopardize the common alliance. Figure 29b shows the
taper when a hue not centrally located is emphasized. It is advis-
able to emphasize the hue which is going to provide the subordinate
chroma. Note that in this illustration the value dominance has
been shifted to value 4 to accommodate the spectrum value of red,
the hue which now carries the high chroma.

Figure 30

WARM AND COOL DISTINCTIONS

"Warm" and "cool" are convenient terms to refer to the opposing halves of the color field as shown in Figure 30, the term "warm" being assigned to those hues associated with physical warmth, the reds and yellows. The terms are somewhat arbitrary, yet useful in practice to designate hue affinities and distinctions which the eye readily detects. The hues RP and G, being borderline hues, may make alliance with, or oppose, either group according to the manner of organization. (The terms are also loosely used to indicate relative distinctions within a single hue sequence, thus, a "cool" red, meaning a red leaning toward RP; a "warm" red tending toward orange.)

In the present problem, when the adjacent hue group spreads across the warm-cool dividing line, the antagonism between the outlying hues is augmented. In this situation it is advisable to curtail the spread, emphasize the hues lying on the borderline between warm and cool, and keep the outlying hues away from each other in the design.

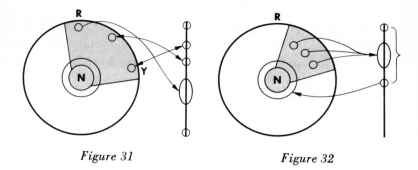

Figure 31 *Figure 32*

WHEN NEUTRALS ARE DOMINANT

Although this scheme could permit use of a neutral dominance just as in the single hue and neutral scheme, there would be some difficulties in working out a scheme of strong contrasts. The subordinate hue and chroma areas would come at several different values (the spectrum values of the several hues); see Figure 31. The bright YR and Y would tend to "jump," that is, demand too much attention, since they would be opposed to all three of the color dominances. An upward adjustment of the value dominance, placing it at value 5, might offer protection to both R and YR, yet Y at value 8 would still be unrelated and the only recourse would be to cut it down to negligible size.

In a scheme of lesser contrasts, however (see Figure 32), the lower chromas of the subordinate hue areas would permit an effective alliance with the value dominance, making possible a valid solution. (In this and in similar situations it is desirable to favor one of the opposing hues and taper the amount of area granted to the others.)

From the foregoing discussion we may rightly assume that the neutral dominance in the adjacent hues and neutral scheme offers certain dangers in situations of strong contrast and little, if any, advantage over the single hue and neutral scheme with neutral dominant. Moreover, we deny the specific virtue of the adjacent hues and neutral scheme which lies in the opportunity for hue variety within the protection of the dominant hue group.

RHYTHM IN COLOR

The discussion of rhythm as an important principle of design has been delayed for the sake of simplified presentation. With the introduction of a number of adjacent hues in our creative problem the discussion of rhythmic order now becomes pertinent.

Rhythm is concerned with the continuity, or on-going quality, of a created work. It is contrived by the designer through the manipulation of the visual elements for the purpose of carrying the observer's eye easily and quickly through the whole design, or through a part of it. In the resulting easy movement the observer senses the completion and oneness of the whole, or of the passage so affected.

Rhythmic order may be built into the presentation of all of the visual elements, if the designer chooses, but the aesthetic goal requires only that the rhythmic continuity of the whole be accomplished and does not prescribe the means. The burden of the rhythmic organization frequently falls more heavily upon the elements of line and mass than upon the color elements. However, we should understand that hue, value, and chroma may equally serve the designer's purpose.

TWO TYPES OF RHYTHM

Rhythm as an organizing force in design has two distinct manifestations: one in which rhythm is achieved through *repetition* of a visual element or complex of elements; the other in which rhythm is achieved through a *sequence,* or progressive change, in an element or complex of elements.

RHYTHM THROUGH REPETITION

The rhythm of repetition is achieved through color when a certain color note recurs at more or less regular intervals throughout the unit or part thereof. An effect of likeness or harmony is created in the unit by the awareness of this common thread in the fabric. Once the regular recurrence is noted, the mind leaps to embrace the whole and reads it as one. This type of rhythm is best observed in fabric or wallpaper designs when a color motif is repeated at regular intervals.

RHYTHM THROUGH SEQUENCE

Much more complex is the sequence type of rhythm. Rhythm through sequence implies a progressive change in the color elements, and it is applicable to all three of the color variables, separately or all together.

Hue Sequence

The order of the hues of the spectrum is a manifestation of physical law. The hues in spectrum sequence, as indicated in the hue-circle diagram, blend imperceptibly into their neighbors so that in reality no boundary lines exist.

The eye finds pleasure in this natural succession of the hues of the spectrum. When the designer plans progressions of hue in spectrum sequence (either clockwise or counterclockwise around the hue circle) the areas so affected become parts of a movement which unifies the passage.

Value Sequence

Rhythmic order of values is established when values are stated in graded sequences, as in any orderly progression of values from dark to light or light to dark. The order implied in this sequence enables the observer to grasp as a unit the passage so affected. Value sequence may be stated in appreciable and clearly marked intervals or in barely perceptible steps of gradation; the sequence may proceed through progressively increasing or decreasing intervals of value.

Chroma Sequence

Rhythmic order may be achieved through progressions from dullness to brightness, or the reverse, through ordered intervals of chroma.

Any two or all three types of sequence may be combined as, for example, in a progression from dark, dull green to a lighter, more intense blue-green, to a still lighter, brighter blue.

Organizing color through sequence rhythm holds fascinating possibilities for designers who work with mobile color in an actual time sequence, as do designers for the ballet, pageant, animated movies, and the color organ.

The adjacent hue and neutral scheme offers the first opportunity we have had to build hue sequences, an opportunity which recurs in the split-complement scheme to be presented in Chapter 14, as well as in all schemes in which a spread of hues within the dominant hue group occurs.

While perfectly valid color schemes can result without incorporating the rhythmic factor in the color elements, the student should, nevertheless, consciously seek to build color rhythms into his designs as opportunity offers. Certain gains in fluency and visual intriguement will result.

PROJECT 10

OBJECTIVE. To create a color scheme in the hue limit of adjacent hues and neutral.

TECHNICAL DIRECTIONS. Explore possibilities of color motif as suggested in Chapter 9 in relation to the neutral problem. Exploit possibilities in the warm hues as well as in the cool hues. Try bridging over the warm-cool borderline. Explore motifs which feature subtle contrasts as well as strong contrasts. In each case predetermine the contrast character as well as all three color dominances. Experiment with rhythmic passages.

Note that in schemes of strong contrast the choice of hue dominance, and especially the hue which will be emphasized in the spread of the adjacent hues, will dictate the value dominance for the unit (the spectrum value of the hue which carries the high chroma) if the subordinate (high) chroma area is to relate to both the value and the hue dominances.

Or, in situations where the value dominance has been predetermined, the choice of hues for the hue dominance, and especially the stressed hue of the sequence, should be made from those hues whose spectrum values coincide with the value of the value dominance.

Make a charting of the proposed organization before mixing paint. Such a charting is shown in Figure 33. Here the adjacent hues, R-RP-P, establish a common hue dominance with emphasis upon RP. The contrast character is subdued, indicating limited ranges in both value and chroma. The chroma dominance is established at the low-chroma level, the chroma balance being slightly above middle chroma. The value dominance is light, opposed by white and a middle value. The arrows make possible the complete color description of each of the subordinate factors in the organization. In the scheme diagramed each opposition factor allies with two dominances, with the exception of the neutrals, which by nature cannot make the double alliance. (Note, however, that the neutral gray, upon which the burden of hue relief falls, is stated in the value of the value

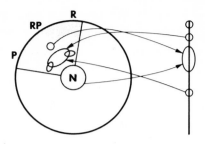

Figure 33

dominance. The other neutral, white, while incapable of allying with any dominance, is nevertheless welcome in this scheme.)

It is good procedure to premix all colors according to the planned organization so that they can be observed and correlated on the palette as wet colors. It is difficult to judge a wet color when associated with colors already dry.

After experimenting with various color motifs, select one for development in a 5- by 7-inch rectangle. Try to achieve a valid organization of the line, shape, mass, and texture elements as well as the color elements.

Letter the title of the scheme, and diagram the organization as in Figure 33. A gridiron analysis such as the following (which is the analysis of the scheme shown in Figure 33) might be included. It will give the student practice in thinking clearly about the order imposed upon each of the color elements.

	Limitation	Dominance	Balance
Hue	Adjacent hues and neutral	P-RP-P (RP emphasis)	N
Value	Value 9 to 5	Value 7	Value 9 and 5
Chroma	N to middle C	Low chroma	Middle chroma and N

The Expressive Potential of Color; Color Planning for the Specific Project; Color Under Artificial Light

A highly important aspect of the color statement, as indicated in earlier chapters, is the expressive meaning which color can convey. A color scheme is felt to be bold, subtle, serene, gracious, sparkling, forceful, harsh, bleak, brutal, gay, or somber according to the designer's purpose.

Such meaning—the mood or spirit of the color scheme—is sensed intuitively by the observer, granted he has normal awareness and perhaps some sensitivity to the play of the design forces.

For the designer, however, the expressive language must have a technical basis, since he must have precise command of his expression. He must understand that the expressive meaning is not something that is added to a color scheme, but is the direct outcome of the technical structure of the scheme. The expression and the structure are inseparable. The expressive goal dictates the structure. The structure carries the expressive meaning.

If we consider that the basic structure of a color scheme consists of the dominances of hue, value, and chroma, together with their subordinate oppositions, the problem resolves itself, conveniently, into two operations, namely, the choices for the dominances and the choices for the oppositions. However, in making these choices the designer must be alert to the expressive connotations which are empathically imputed to the color relationships.

THE ROLE OF EMPATHY

The expressive meaning of color derives from the human tendency to identify with, and to read human meaning into, the play of the abstract forces of design. This is known as *empathy*. It behooves the designer to consider empathic directives in his choices both for the dominances and for the oppositions.

EMPATHY IN THE CHOICES FOR DOMINANCES

Logically the dominances carry a great deal of the expressive burden, since they state the main impact of the scheme. There are human connotations associated with the warmth of the sun, the colors of the earth, the lightness of day, the darkness of gloom, the coolness of a dream, the brightness of joy, and the colors of springtime, to name but a few. Such associations are deeply rooted in human emotions, perhaps as a legacy of racial experience and memory. Some are the result of cultural attitudes and beliefs.

In a given project the empathic directives may not be compulsive, or even evident. Nevertheless, the designer certainly needs to raise the possibility of an empathic reading of his choices for dominance.

If, for example, his project is calling for warmth and light-hearted gaiety, he should recognize the empathic directives favoring a light value dominance and a warm hue dominance, since it might be difficult to convey the intended meaning with dominances of dark values and cool hues.

EMPATHY IN THE CHOICE OF THE OPPOSITIONS

We have discussed in earlier chapters the expressive meanings which can be conveyed by the force of the contrasts—meanings

which are dependent upon the degree of the oppositions, from startling boldness to subtle delicacy. The contrast character, determined by the degree of shock or opposition, normally demands a certain consistency if the reading is not to be confused. Nevertheless, there are interesting technical exceptions to strict consistency in handling the oppositions in the various elements.

Certain elements of form seem incapable of achieving subtle contrasts without undue loss of the sense of opposition. Elements such as line, shape, mass, and hue will demand positive oppositions regardless of the expressive intent of the scheme. These elements cannot adjust to a lesser degree of contrast without impairment of the oppositional function. However, the ranges of value, chroma, and texture easily adjust to lesser contrast while preserving the sense of opposition. Therefore it is in the control of these three elements (value, chroma, and texture) that the expressions dependent upon subtle and subdued contrasts are possible. Normally the contrast character of the scheme of subdued contrasts should be maintained consistently in these three elements.

In schemes of strong contrast, all elements will normally maintain forceful opposition; yet there may be exceptions dependent upon the expressive goal of a given project. Sometimes a cultural viewpoint conditions the result, as when accepted or customary usage supplants an aesthetically valid, though nonconformist, solution. For example, many painters of themes of sobriety and somber dignity from the seventeenth through the nineteenth centuries customarily avoided the high-chroma contrast, even when employing vigorous contrasts elsewhere; but both before and since (in the Italian Renaissance of the fifteenth and sixteenth centuries, as well as in the earlier Byzantine painting, and now in the twentieth century), painters of the Crucifixion theme, for example, have availed themselves of the full chroma potential.

Granting that line, shape, mass, and hue will always demand positive oppositions, there is still a possible upward extension of contrasts possible to some of them when the occasion demands. Thus, in line, the static but positive opposition of verticals and horizontals can be made dynamic and more vigorous by the use of opposing diagonals; complementary hue oppositions can go beyond

the contrast possible with the neutral as hue balance. Mass relationships may exaggerate the mass conflict when desired. Shape, however, cannot go beyond the minimum necessity of curved versus straight.

COLOR PLANNING FOR THE SPECIFIC PROJECT

The foregoing discussion of the technical side of the color expression will become more meaningful when we consider color planning for an actual and specific project. Indeed, in actual experience we are called upon to create color only for the specific project—a color solution is demanded for a certain concrete and specific situation.

Such a particular project always has its own purposes and functions to which the color must be appropriately attuned. In dealing with any phase of creative design, the designer always starts with the considerations of function—a study of the purposes and satisfactions which his design is expected to achieve.

An intelligent appraisal of these purposes and functions yields many positive directives for his form.

FUNCTIONAL DIRECTIVES AT THE UTILITARIAN LEVEL

There may be in a given project some purely utilitarian aspects of function which will yield important directives for form. For example, in planning color for a living room with small windows and north exposure, functional considerations immediately suggest a light value dominance and a warm hue dominance.

Such utilitarian directives, when accepted as valid, mark the first step in color planning and normally take precedence over other considerations. That is, the utilitarian directives establish certain features of the organization which are incorporated in the scheme, whatever the expressive goal may be.

In rare situations when there is a conflict between the utilitarian demands and the expressive goals, the designer must arrive at a reasonable compromise.

FUNCTIONAL DIRECTIVES AT THE EMOTIONAL LEVEL

A true understanding of functionalism as a philosophy of design recognizes that both utilitarian and emotional needs must

be served. The emotional need is served in two ways: first, in the expressive meaning which is conveyed and, second, in the achievement of visual unity.

The appropriate expressive content of the color scheme must be chosen to serve functionally the needs and purposes of the project. Once the expressive goal has been determined, certain clear directives for form emerge. The designer checks for possible empathic directives in the choices for the dominances and in the choice of the appropriate contrast character for the unit.

At this point in the planning procedure, certain aspects of the formal structure of the color organization have been determined, while others will permit some freedom of choice. But the frame within which the designer may work has been set, and within the limits of this frame he may work creatively and purposefully. When the designer works within such a frame of structural goals, he can indeed be free to follow his emotional directives in the building of the intimate color-to-color relationships of his design.

In the following projects color solutions are desired for specific problems. The student should follow the procedures as discussed above and as indicated in the directives which accompany the projects. A detailed example of creative procedures in planning is given under Project 11. The conclusions arrived at and the solutions suggested, however, should not be regarded as the only valid ones. The important thing is to understand and master the successive steps in creative planning.

PROJECT 11

OBJECTIVE. To create a color scheme for a poster for a school dance, a spring formal.

TECHNICAL DIRECTIONS. Work with any type of scheme so far studied which best serves the project. Put colors together as a color motif. Do not design the poster. Follow procedure as detailed below and in the example which follows. The example is designed to show a way of thinking through the creative problem in an orderly way. Its conclusions need not be yours.

PROCEDURE.
A. Appraise functional aspects of project to determine directives for form, if any, at utilitarian level.

B. Appraise functional aspects of project to determine the appropriate expressive goal.

C. Expressive goal will yield directives for form via
1. Empathy in choices for dominances.
2. Empathy in choices for oppositions.

D. Chart possibilities and make final decisions.

E. Produce the colors indicated and make a spot motif giving each color its appropriate area.

AN EXAMPLE TO ILLUSTRATE PROCEDURE.

A. Appraisal of functional aspects of the project at the utilitarian level.
1. Poster needs to get attention, therefore needs strong contrasts. Directive for form: wide ranges of value and chroma.
2. Poster needs simple direct statement, no place for elaborations and subtleties. Directives for form: a limited hue range; for example, a single hue and neutral or adjacent hues and neutral.

B. Appraisal of functional aspects of project to determine the appropriate expressive goal.
1. The poster needs to touch the emotions and the imagination of the observer in order to make him want to attend the spring formal. Let us consider some of the connotations of the occasion which might have an emotional and imaginative appeal, together with the directives for form which might stem from each.

 Gaiety and laughter, sparkling animation of the dance. Directives for form: light value dominance, sharp, snappy contrasts in value and chroma.

 Enchanted evening, fantasy, out-of-this-world quality. Directives for form: hue dominance: R-RP-P or BP-G-BG.

 Connotations of springtime, colors of spring flowers, delicacy. Directives for form: hue dominance: G-GY-Y or R-RP-P; *limited ranges of value and chroma.*

 Romance of a spring night. Directives for form: hue dominance: B-BP-P or B-BG-G; value dominance: dark or middle value.

 Sophistication, dignity, and smartness might have a part in the final determination. If so, their effect would be to modify the utilitarian demand for bold contrasts in order to avoid the blatancy of harsh, bold oppositions while still maintaining sufficient contrast to satisfy the attention-getting requirement.

C. It is not always that a project yields so many possibilities for expressive connotations as this one. The important point, however, is that, whatever the expressive goal, certain directives for form emerge.

D. The next step, of course, is to chart the various possibilities, planning the complete scheme in each case, and then to make the final decision.

PROJECT 12

OBJECTIVE. To plan color for an interior—a warm, friendly living room—with given lighting and exposure.

TECHNICAL DIRECTIONS. Utilitarian considerations will yield certain directives for form in situations where the window space is inadequate, or where it is excessive, and where the exposure favors the sun or avoids it.

This project is admittedly academic since in an actual situation many additional factors will enter into the solution, such as the personal desires of the family, the uses to which the room must accommodate, the furnishings that may already be present and must stay, the availability of desired colors in fabrics and other materials. And yet the experience of working out planned solutions to hypothetical problems will serve to orient and guide the creative procedures when meeting an actual problem.

PROCEDURE. Follow the same procedure as in Project 11. Plan color for a variety of different interiors—for example, the decor for a night club, the waiting room of a doctor's office, a little girl's bedroom.

PROJECT 13

OBJECTIVE. To plan the color for a stage setting, for example, the witches' scene in *Macbeth*.

TECHNICAL DIRECTIONS. Give special attention to the expressive needs of the setting. Color can do much to establish the emotional tone of the scene. In the problem suggested above, an emotional goal might be stated in such words as weird, somber, and terrifying. Empathically derive directives for form which encompass these meanings.

Since the color problem here is involved with artificial lighting, certain new factors are involved. Read the discussion following on Color Under Artficial Light.

PROCEDURE. Follow general procedure as outlined under Project 11. Plan the lighting for the set so that the desired colors will receive the kind of light your pigments can reflect.

COLOR UNDER ARTIFICIAL LIGHT

Color creations involving colored light, as in stage settings, window displays, etc., usually involve both the pigment response to light and the mixtures of light itself.

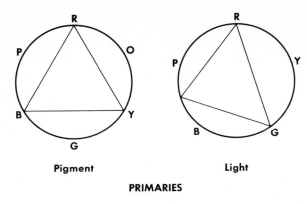

Pigment **Light**

PRIMARIES

Figure 34

As noted in Chapter 4, there is a difference in the way light and pigment behave in mixtures. Specifically there is a difference in what are known as the *primaries*, or the hues from which all other hues may be derived, yet which cannot themselves be produced by mixture.

In the case of pigment, the primaries are red, yellow, and blue. Mixtures of these colors yield the intermediates orange, green, and purple.

The light primaries, however, are red, green, and purple-blue. Light mixtures of the primaries yield the intermediates yellow, blue, and purple. See Figure 34, which shows both the light circle and the pigment circle with their respective primaries.

The light mixtures of primaries R and PB to produce the purple range and G and PB to produce the blue–blue-green series seem reasonable and expected; but the unusual result of the mixture of R and G light to produce yellow needs special attention, since it is so different from our experience with pigment mixture.

Let us first review the situation which normally obtains in stage lighting. Pigmented stuffs, as in the painted stage scenery and in the colored fabrics of costumes, receive light from artificial (colored) light sources. Such pigmented surfaces behave as all pigment behaves. A pigment can reflect only its own kind of light. This means that it can read as its true color only when it receives the light vibrations to which it is attuned. These it can extract from

white light, but, under conditions of artificial lighting, pigmented gelatins over the light sources may have already subtracted some of the vibration range of the spectrum, so that a given pigmented surface may not receive its own kind of light. In that case, since the pigment cannot return the vibrations foreign to its nature, it returns nothing and reads as a neutral area.

RED + GREEN = YELLOW

To return to the peculiar case of yellow, let us suppose a yellow costume is in question. The yellow pigment in the costume will, of course, appear yellow under yellow light and also under a white light, but it will also respond to red and green light since yellow is a complex of both of these light vibrations. Thus, the yellow costume will look red under a red light and green under a green light, but, of course, gray under a blue light. Or, supposing a yellow light falls on a red-pigmented surface. Since the yellow light is composed of both red and green vibrations, the red-pigmented surface can receive its own kind of light and will read as red. So, too, a green pigmented surface under a yellow light will read as green. (A red-pigmented surface under a green light, however, would read as a neutral, as would a green-pigmented surface under a red light.)

In general, in planning color to be seen under artificial lighting, we must provide either white light or the light to which the pigments are attuned if the colors are to appear as planned.

The Organization of the Complementary Schemes

The problem of organization becomes increasingly complex as we extend the hue field to include hues from opposite sides of the color field. The element of variety is increased. More unlike elements must be related and coerced into a unity.

A SINGLE HUE AND ITS COMPLEMENT

Let us first consider the problem posed by the simple opposition of a hue and its complement. The hue limitation as diagramed in Figure 35 defines a pathway directly through the color field, embracing the value and chroma ranges of both hues and including the range of neutrals. The neutrals, which in the schemes previously discussed served as hue balance, now serve in other capacities as discussed later in this chapter.

The choice of hue dominance may rest upon either of the complementary hues or upon neutral.

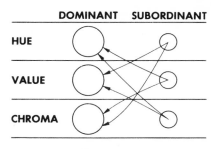

Figure 35 Figure 36

DOMINANCE UPON ONE OF THE COMPLEMENTS

Here we proceed exactly as in the single hue and neutral scheme as far as the organization of the dominant hue is concerned. The handling of the opposition hue, however, will require that it make alliance either with the value dominance or the chroma dominance (to avoid being opposed to all three dominances). For complete accord and ease of handling, it is, of course, decidedly better to protect the subordinate-hue area by having it state the value of the value dominance *and* the chroma of the chroma dominance, thus to achieve the double alliance. Figure 35 illustrates such an organization wherein all subordinate areas are related to two dominances.

The technique of the double alliance for the subordinate areas is shown graphically in Figure 36. The arrows point to the dominances with which each subordinate area allies. Thus, the subordinate hue area states the value of the value dominance and the chroma of the chroma dominance.

The subordinate value area is part of the hue dominance and of the chroma dominance.

The subordinate chroma area allies with the hue dominance and with the value dominance.

NEW FUNCTIONS FOR NEUTRALS

When the hue range includes complementary hues, the neutrals, of course, no longer function as hue balance. They are, nevertheless, welcome areas in the color scheme, though their service is difficult to define. In some way they serve to help colors get along

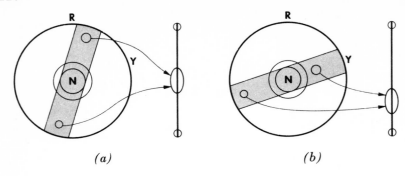

Figure 37

well with each other. It is, perhaps, because they provide the perfect foil against which hue and chroma statements can be measured in respect to their departure from huelessness and chromalessness. It may also be that the neutrals provide the restful intervals, as in music, against which the other colors are enhanced. Neutrals may also serve as buffers to cushion the shock of opposing hues by preventing the juxtaposition of such hues.

THE CASE FOR NEUTRAL DOMINANCE

In the case of neutral dominance a secondary emphasis should be arranged so that both hues will not be equally represented, see Figure 37a. Equal representation of the two complementary hues, even as subordinate areas, would maintain an unresolved antagonism precluding a complete unity.

In schemes of strong contrast character, it is in some instances impossible to grant a protective alliance to both complementary hues which in this situation would normally be stated at high chroma. Owing to their different spectrum values, perhaps only one may be related to the value dominance. In such a situation, as diagramed in Figure 37b, it will ordinarily be wiser to sacrifice chroma in one of the complements so that both hues can make the alliance with the value dominance, which in this situation is the only dominance with which they can possibly ally. However, if we choose complements (or near complements) whose spectrum values are about the same, we can provide a protective alliance for both of them by establishing the value dominance at this value level.

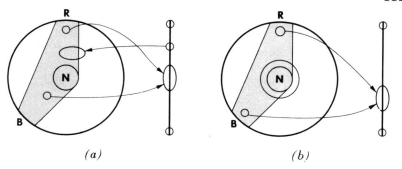

(a) *(b)*

Figure 38

A SINGLE HUE AND ITS NEAR COMPLEMENT

Hues which are not true complements but are nearly so, as in the case of the hues which are just a step removed from being diametric opposites, may be organized in much the same way as a pair of true complements. Care should be taken to ensure the near complementary character of the hues in this scheme, for if the hues are more than a step removed from the state of true complements, they tend to make an analogous alliance against the neutral instead of opposing each other. Note, however, one exception discussed in Chapter 16.

Figure 38 diagrams two effective organizations for this type of scheme. In (a) the hue dominance is R; in (b) the neutrals are dominant. Figure 38b charts a scheme of strong contrasts in which both subordinate hues might carry the high-chroma opposition. This is possible since both hues have the same spectrum value and so can achieve alliance with the value dominance. A study of the scale of spectrum values will show that there are only a few such pairs of complements, or near complements, which can be so used. Moreover, the few pairs whose spectrum values are reasonably close are the only ones which have much chance of success with a high-chroma dominance.

THE SPLIT COMPLEMENT

The term *split complement* was first applied to the scheme in which a hue was opposed by two near complements (one on either side of the true complement), which jointly provided the comple-

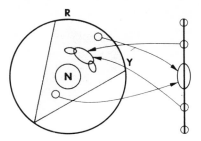

Figure 39

mentary function. Enlarging the meaning of the term, any group-ing of a number of adjacent hues against a single hue on the oppo-site side of the color field could with reason likewise be termed a split complement, since the complementary function on one side of the field is split or divided among the several hues neighboring and including the true complement. The term "split complement" is generally applicable to all those complementary groupings of hues in which two or more adjacent hues oppose a lesser number.

There are a number of patent virtues which make the split complement possibly the most favored of all color plans. Within a considerable actual limitation of the hue range it yields an apparent multiplicity of hue. It combines relative ease in main-taining order with ease in securing variety.

Normally the dominance is established upon the group of adjacent hues, since one of the virtues of this scheme lies in the possibility of hue variety within the areas of the hue dominance. The handling of the dominant hue group is exactly the same as in the adjacent hue and neutral scheme of Chapter 12.

The opposition hue (or hues) must ally with the value domi-nance or with the chroma dominance or with both, if possible. If it fails to do so, it stands opposed to all three dominances, and it will refuse to become a part of the scheme.

Figure 39 charts an effective organization of the split-complement scheme in which all subordinate areas are related to two dominances. The arrows, remember, lead from the subordi-nates and point to the dominances of which they are a part.

It will be observed in this diagram that the field of hue limita-
tion, as shown in the shaded portion, spreads over the low-chroma
field of certain out-of-scheme hues. Such out-of-scheme, but low-
chroma, hues are welcome in the color scheme when variety
demands. Organization capable of accepting the greater antago-
nisms provided by the complementary opposition cannot be dis-
turbed by the lesser antagonisms of the low-chroma out-of-scheme
hues. Such areas, however, must be used with discretion so that
the hue dominance is not jeopardized. They must not be regarded
as discords, since they are not strong enough to inject a dissonance,
unless, of course, the chroma range of the whole unit is so restricted
that their relative force is magnified. In such a case they become
functioning discords as described in the next chapter.

PROJECT 14

OBJECTIVE. To create a color scheme in the single hue and its comple-
ment limitation.

TECHNICAL DIRECTIONS. If hue dominance is established upon either
complement, the organization of the dominant hue proceeds as in the scheme
of a single hue and neutral, see Chapter 11. The handling of the subordinate
hue area will, of course, demand a protective alliance with either the value
or the chroma dominances, or preferably with both. The usual checks for
amount, placement, and *distribution* for all subordinate areas should be
made.

If hue dominance is assigned to the neutrals, the subordinate hue areas
(which in this case are also subordinate chroma areas) must make alliance
with the value dominance. In the case of strong contrast character, which
will demand a high chroma in the subordinate hue areas, the complements
chosen must be those whose spectrum values lie fairly close together on the
value scale, and the value dominance must be established at this value
level. (See also an alternative solution as charted in Figure 37b.)

PROCEDURE. Diagram possible solutions, exploring a variety of paired
complements and different expressive goals.

Make choice of plans. Make paint mixture as indicated in chosen plan,
keeping all wet in pockets of palette before beginning to paint.

Mentally impose design order upon line, shape, and mass, thus to pre-
plan the limitations, dominances, and balances of these elements.

Start building your design within a preestablished frame of organiza-
tion. Work freely, imaginatively, as the design grows to completion. Try
to build into your work some of the designer's technical devices, as dis-

cussed in Chapter 8, for greater visual interest. Include a texture foil to the smooth paint surfaces, adjusting the texture contrast to the contrast character of the whole.

PROJECT 15

OBJECTIVE. To create a color scheme in the single hue and near complement limitation.

TECHNICAL DIRECTIONS. As in Project 14.

PROCEDURE. As in Project 14.

PROJECT 16

OBJECTIVE. To create a color scheme in the split-complement limitation.

TECHNICAL DIRECTIONS. Organize the dominant hue group as in the adjacent hues and neutral scheme, Chapter 12. But this time make a special effort to build some rhythmic sequences of hue.

PROCEDURE. Follow general plan suggested in Project 14.

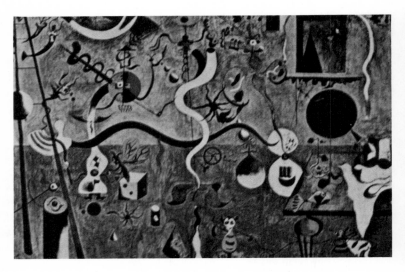

HARLEQUIN'S CARNIVAL, *by Joan Miro,*
Contemporary Spanish Painter

This colorful and lively canvas is a fine example of the split-complement scheme. The dominances are all clearly established, and all oppositions are related to two dominances.

chapter 15

Discords in the Color Scheme;
The Triad and Its Variations

The widening threshold for the experience of discord within
an art form is common to many of the arts of the twentieth century.
In music we are accepting dissonance which was not tolerated at
an earlier point in history. The same increasing tolerance of dis-
cord has accompanied the use of color. The discordant note has
come to enrich harmony, add variety and zest, and make the color
medium more expressive of the complex emotional life of today.

The discord, to be a functioning part of a color scheme, has to
be a kind of irritation, an unmollified intruder into an otherwise
harmonious setting. It must do its job without upsetting the
established structure of the organization.

Dissonance is always a relative matter. In a loosely organized
color arrangement it may be impossible to achieve a functioning

discord, whereas in a highly organized unit, a very slight departure from the established order may produce an effective discord. Discords need to be carefully and judiciously interpolated into the organization. They must not be random selections but must be thoughtfully, even intuitively, chosen for the part they are to play.

Theoretically we should be able to have discords in value and in chroma as well as in hue, but for practical purposes it is the hue discord that really matters. An out-of-scheme value or chroma tends to be read as a simple extension of the value or chroma range. But the hue discord immediately proclaims itself as an out-of-scheme hue.

TECHNICAL CONSIDERATIONS

Naturally, the hue chosen for dissonant purpose must be far enough removed on the hue circle from both dominant and subordinate hues that it will not be confused with either. In chroma it needs sufficient strength to make its presence felt. Thus, perhaps it must be stronger than the chroma dominance, yet not so strong as to carry the burden of subordinate chroma in the scheme, although even this is a possibility.

Since such a color will be necessarily unrelated to the hue dominance and the chroma dominance, it should normally ally with (be a part of) the value dominance. If the discord areas are small enough, even this tie with a dominance can be ignored in schemes where extreme dissonance can be tolerated.

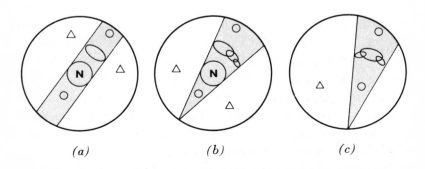

(a) (b) (c)

Figure 40

BALANCED DISCORDS

The inclusion of a discord hue naturally affects the general balance of the hues, accentuating one side of the hue field at the expense of the other. To preserve balance, a second discord chosen from the opposite side of the field is usually welcome. The balance discord may be complementary to the first, or it may be the hue that will provide a symmetry in the figuration of the hue circle. Figure 40 shows examples of discord placement. The discords are charted as small triangles. When the basic scheme itself is off center, a single discord will restore the balance.

PROJECT 17

OBJECTIVE. To create a color scheme with functional discords of hue.

TECHNICAL DIRECTIONS. Work with any type of scheme so far studied. Experiment with discords in a variety of types of scheme. Discords may be interpolated into color projects already completed, but it will be better, in order to preserve the sequence of your studies, to design a color scheme expressly for the purpose.

PROCEDURE. Complete a well-ordered color scheme before introducing discords. Study the charting of the scheme to discover the favorable locations for the discord areas as indicated in the text, and set them into the design where they will accomplish the dissonant function. The checks for amount, placement, and distribution will be pertinent.

THE TRIAD

The possibility of triadic oppositions of hue occurs when three hues which lie approximately equidistant from each other on the hue circle are chosen. (Any closer proximity encourages alliance with the near neighbor rather than opposition to it.)

The virtues of the triad scheme lie in the vitality of the three-way hue opposition. It is used most effectively in situations demanding vigor, sparkle, and animation. The added oppositional play poses some threat to order demanding a secure dominance upon one of the three contenders. The other two must share the subordinate role.

The hues in opposition to the dominance are at the same time in opposition to each other. This minor battle must be resolved in

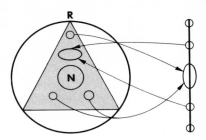

Figure 41

favor of one or the other, tapering the amount of area assigned so that one is emphasized over the other. See Figure 41.

In all other ways the subordinate hues need the same care in handling that has been necessary in the schemes we have already studied.

VARIATIONS OF THE TRIAD

A permissible variant of the triad occurs when the dominant hue group spreads to include an adjacent hue, or perhaps one on either side of the original hue. In such an extension of the hue dominance the true triadic (or center) member should be emphasized, Figure 42a. (Such a scheme might also be read as an adjacent hues and neutral scheme with balanced discords, Figure 42b.)

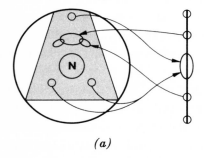

(a)

(b)

Figure 42

Figure 43 Figure 44

Figure 43 shows a triad scheme with the neutrals dominant. Appropriately it is a scheme of sharp contrasts requiring high chroma in the subordinate hue areas. Since these areas are opposed to both the hue and the chroma dominances stated by the neutrals, they need to relate to the one dominance possible, namely, value.

The solution depends upon finding a hue triad whose members can attain a fairly high chroma at the same value level and establishing the value dominance for the unit at this value. The solution diagramed shows magenta, turquoise, and chartreuse (to use currently popular color names), all of which can achieve high chroma at the dominant value (value 7).

THE LIMITED TRIAD

The limited triad, shown in Figure 44, is, in effect, a miniature of the triad. Alternate hues, with neutral as a third member, make up such a triad. In each case the N takes on the quality of the opposition hue; thus, it becomes a cool relief with R and Y but a warm relief when used with B and G.

Although the hue field is limited as in the adjacent hues and neutral scheme, the organization proceeds as with the triad, since no bridging hues are involved and the three hues are equidistant on the hue circle. The hue dominance should be established upon one of the hues rather than on the neutrals, if the neutrals are to respond in a complementary capacity.

THE LIMITED TRIAD AS A "SET" PALETTE

Painters sometimes arbitrarily limit the range of colors on their palettes. The limited triad R-Y-N has been used by painters for centuries, since the intermixtures of these pigments yield the suggestions of the complete hue range while actually exploiting a very limited section of it. Thus, N reads as a blue in opposition to a warm-hue dominance. Mixtures of N and Y produce relative greens; N with R yields relative purples.

An interesting variant is found in the R-Y-G triad, where a dull green is substituted for the N. In practice it is advisable to premix a series of values of each of the pigments used; thus, a column of reds, a column of yellows, and a column of neutrals (or greens).

Figure 45

SATURATION: A DEVICE OF PIGMENT MIXTURE

An approximation to the field of the limited triad is achieved when one pigment is mixed with each of any random hues selected. Figure 45 shows the resulting mixtures when red is the saturating color.

Notice that the mixtures, shown on the pigment circle, define a smaller circle pulled toward the saturating hue, thus limiting the actual color field while retaining the power to suggest a much wider hue range.

In making the saturated mixtures, care should be taken that each color is pulled about halfway toward the saturating color. Normally, then, since the original hues suffer considerable loss of

chroma (some achieving neutrality and others nearly so), any chroma relief must be carried by the saturating hue. This hue is also the hue which can best establish hue dominance and thereby cause the neutrals and near neutrals to function as the complementary hue opposition.

PROJECT 18

OBJECTIVE. To create a color scheme in the triad limitation.

TECHNICAL DIRECTIONS. Explore your pigments to discover the various triadic possibilities. Since the added potential in hue opposition is the particular virtue of the triad scheme, plan a scheme of snappy, animated contrasts.

PROCEDURE. Since, in the schemes of greater contrast character, it is important to establish value dominance at the spectrum value of the dominant hue, the decision as to value dominance may precede your choice of a dominant hue. This, in turn, will largely dictate what the other hues in the triad will be.

State the range of chroma and the range of value in the areas of the dominant hue, while the remaining members of the triad share the subordinate hue role. The subordinate hues should not be equally represented. Favor one of them.

PROJECT 19

OBJECTIVE. To create a color scheme using the limited triad.

TECHNICAL DIRECTIONS. Any pair of alternate hues as shown on the hue circle, together with neutral as the third member of the triad, may be used.

Hue dominance should be established upon one of the hues rather than upon the neutral, if the neutrals are to appear in the complementary role.

If neutrals establish the hue dominance, the resulting scheme will be similar to the adjacent hues and neutral scheme with N dominant, and it will meet the difficulties in strong contrast situations described in Chapter 12.

PROCEDURE. Choose your dominant hue, and let it state the range of values and chromas for the unit, thus putting on the "big show" under protection of the dominant hue alliance. In schemes of strong contrast plan the value dominance to coincide with the spectrum value of the dominant hue. Or, conversely, if the value dominance is determined, choose for dominance a hue whose spectrum value is at this value level.

The second hue shares the subordinate hue role with the neutrals. Let it ally with the chroma dominance and perhaps the value dominance as well. The neutral gray at the value of the value dominance will be the third mem-

ber of the triad. Black and white will also be welcome in schemes of strong contrast.

PROJECT 20

OBJECTIVE. To create a color scheme using the device of saturation.

TECHNICAL DIRECTIONS. You may use any pigment as the saturating pigment. Mix it into a variety of other pigments so that each mixture is drawn halfway toward the saturating pigment as recorded on the *pigment* circle.

Since these mixtures result in colors of low chroma, provide some low chroma of the saturating pigment as well. The resulting colors in combinations, as in a color scheme, take on the appearance of the original hues even though they are all found in a very limited sector of the color field.

You must still impose design order upon these colors in order to achieve a visual unity. The dominant hue group should include the saturating pigment, which is the only one which can have the possibility of some range of chroma. It will be found, however, that only a limited chroma range is necessary, since the saturated colors are very subtly contrasted and lose their nuances and delicate charm in contact with bold contrasts. The separate mixtures may look very discouraging, since they are so low in chroma, but when they are placed next to each other in your color scheme, the subtle hue differences become enhanced.

Determine the type of scheme that will best serve your purpose. Some slight elaboration of the value of certain of your colors may be essential, but do nothing to disturb the hue and chroma as established on the pigment diagram.

Exploring the Wider Ranges of Hue; Variants of the Basic Schemes

TWO ADJACENT HUES AND THEIR COMPLEMENTS

If we extend the hue range to include two adjacent hues and their complements, as shown in Figure 46, we have, within a comparatively restricted hue range, a color scheme that seems to give the effect of great hue variety, this probably because of the reciprocal play of four complementary hues. It is especially successful where the need is for full rich color effects.

The possibilities of a wide choice of hue dominances make it an attractive scheme for many purposes. For example, the hue dominance may be established upon either group of adjacent hues, or upon neutral. Alternatively, one set of complements may be emphasized while the other is played down, and within each complementary pair we have the choice of either one for hue dominance. Still further variations on the theme could be achieved by

124

Figure 46 Figure 47

allowing a single hue and its near complement to carry the main import of the scheme while the other hues assume a minor role.

In such projects as pageantry, the dance and ballet, and the lively "spectaculars" of stage and screen, with costumes and properties planned within this hue limitation, an ingenious manipulation of the players could present a rich succession of color effects as the dominances were shifted various ways.

THREE ADJACENT HUES AND THEIR COMPLEMENTS

If we expand our field to include another set of complements, Figure 47, we are perhaps at the limit for hue diversity which can easily be managed. If we establish the organization as shown in the diagram, with the central hue emphasized, there will be no difficulties; yet we should understand that as we increase the diversity of hue, it becomes more and more imperative to impose the full strength of design order upon the color variables.

THE POINT OF DIMINISHING RETURNS

If we try to enlarge the hue field still further, say to four adjacent hues and their complements, we shall find that we have reached the point where hue variety becomes a liability rather than an asset—when the problem of enforcing order becomes more difficult and the sense of ordered presentation becomes endangered.

Such a point of diminishing returns seems to be reached when we go beyond three adjacent hues and their complements. Let us

say that, while it may still be possible to coerce four hues and their complements, or even the entire hue range unlimited, little is gained and much may be lost.

VARIANTS OF THE BASIC SCHEMES

Our study of the color field has led us through a succession of color schemes in ever-expanding ranges of hue. It was necessary to establish such color schemes so that we might learn the techniques of organization which each demanded. If we understand the problems involved in these basic schemes, we can easily adjust to the variant possibilities which propose some slight departure from the types of organization we have studied.

Such variants do not deny the organizational truths we have learned, but add flexibility to their application.

ASYMMETRICAL BALANCE OF HUE

Particularly variable are the possibilities for achieving hue balance in unsymmetrical figurations on the hue-circle diagram.

Balance of hue is normally a balancing directly across the color field. We have, however, noted that the neutrals may also serve as hue balance. We have also noted the triadic type of hue balance, as well as the asymmetrical hue balance in the single hue and its near complement.

It is possible to depart even further from complementary oppositions in certain situations. Such situations occur when the warm versus cool opposition is clearly operative. Suppose, for example, a group of warm adjacent hues establishes the hue dominance as shown in Figure 48. The symmetrically determined hue opposition would be B. Our experience with the near-complementary opposition would make it understandable that BG or PB could serve equally well as the hue balance. But, because of the phenomenon of simultaneous contrast, a *green* may be used for this purpose. Against the warm dominance, the green will read cooler than it is, and so it will serve as the cool-hue opposition to the warm-hue dominance. Logically, purple could serve in the same way, although it is less frequently so used.

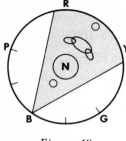

Figure 48

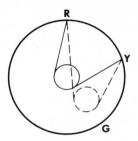

Figure 49

A VARIANT OF THE ADJACENT HUES AND N SCHEME

Another variant related to the above is the case of a low-chroma G serving as the hue balance in the place of neutral in what normally would be the adjacent hues and neutral scheme, Figure 49.

THE SCATTERED HUE BALANCE

Occasionally we find a color scheme which ensures its hue organization by a secure hue dominance while the opposition hues seem to be scattered at random over the whole hue field utilizing an all-around type of balance. Such an organization might be difficult to fit into one of our type schemes; yet if the opposition hues are handled in the manner already approved, there is no reason to question the validity of such a scheme.

Figure 50

UNRELATED PAIRS OF COMPLEMENTS

While such choices of hue as are shown in Figure 50 might be possible in terms of hue limitation, the actual organization of such a scheme would demand that one pair of complements develop the scheme as a single hue and its complement while the other pair of complements plays the role of balanced discords. Another solution would demand the addition of hues to bridge between any two of the hues, and so establish a common hue dominance of adjacent hues, while the other hues serve as hue balance or even as discords.

In general, our reception of variant possibilities should be tolerant as long as the demands of design order are met. The abiding imperatives seem to be the achievement of secure dominances. When the dominances are secure, considerable latitude is permissible in the handling of the subordinate factors. It is wise, however, to respect the need of each subordinate area to ally with at least one of the color dominances. Failing this, the only recourse is to cut down the size of the errant factors to negligible area.

PROJECT 21

OBJECTIVE. To create a color scheme in the hue limitation of two adjacent hues and their complements.

TECHNICAL DIRECTIONS. This scheme of four hues can give the effect of full rich color while actually exploiting but a fairly limited range of hue.

Before making your choice of hues, mentally assess the resources of the many possibilities of adjacent pairs of hues and their complements, noting the values at which the various hues can achieve their full chroma potential.

This knowledge is, of course, important in planning schemes of strong contrast. Within any set of four hues there will be some variation in spectrum value which will have a bearing upon the choice for hue dominance as well as upon the choice for value dominance.

The various ways of throwing the hue dominance and hue balance, as discussed earlier in this chapter, should be given consideration in planning your scheme.

PROCEDURE. As in all color planning, consider first the expressive character you intend to achieve in your color scheme. The expressive goal may influence your choices for all of the dominances and will certainly dictate the character of the contrasts. Visualize the possible choices for dominances of hue and of value which might best convey your expressive meaning.

Your knowledge of the pigment resources of the various hues will enable you to make a valid choice of complementary pairs which can meet both the technical and expressive demands of the problem.

PROJECT 22

OBJECTIVE. To create a color scheme in the hue limitation of three adjacent hues and their complements.

TECHNICAL DIRECTIONS. The great diversity of hue which this scheme allows is nevertheless a threat to the order of the color unit. However, with secure dominances and the proper coercion of the subordinate factors, a valid color statement can be made. It might be well to start your exploration of the wider ranges of hue by keeping close to the order as charted in Figure 47. Then with the knowledge that you can control the wider ranges of hue, you can experiment with variations according to your personal feeling and as may be indicated in a particular situation or in the working toward a particular expressive goal.

PROCEDURE. Follow the general plan indicated under Project 21.

Munsell, Ostwald, and Ross: A Comparative Survey of Competing Systems of Color Standards

The need for an adequate system of color description and standardization has inspired a great deal of study of the problem for more than a century, and it is still engaging the attention of scientists, artists, and students in the field who are seeking perfection in an area which seems to defy perfection.

Of the systems widely used today probably the foremost are those of Munsell, Ostwald, and Ross. Each has its devotees and supporters. Each has its virtues and defects. Each serves certain purposes better than either of the others. All three systems were developed about the same time—early in the present century—and each provides a valid means of describing and classifying the variant potentials of color.

The systems differ because of a difference in approach to the complex truths of color. The Munsell standards are based upon the behavior of light, while the Ross standards are based upon the

behavior of pigment. The Ostwald standards are based upon the unusual premise that all color variation can be accounted for by controlled mixtures of black, white, and the pure color.

THE OSTWALD SYSTEM

Wilhelm Ostwald, a German scientist, proposed a hue circle of 24 hues which, for practical purposes, could be reduced to a lesser number. A circle of 8 hues, for example, could be made by taking every third member of the original 24.

The variant possibilities for each hue of the Ostwald circle are charted on a triangular scale somewhat similar to Munsell's constant-hue chart. Eight steps on a gray scale, from black at the bottom to white at the top, provide a vertical side of the equilateral triangle, while the full color is placed at the outer point.

Graduated percentages of white, black, and the pure color establish the degrees of the scale. When the triangles for all of the hues are assembled in circular fashion with the gray scales forming a central axis, a double-coned solid, slightly comparable to the Munsell color sphere, is formed.

In establishing the degrees of the scale, Ostwald utilized the logarithmic progressions known as Fechner's law, and he found that the resulting colors could be equated with equal steps in the visual sensation as they progressed from purity to neutrality and varied in lightness and darkness according to the percentages of white and black in the mixtures.

Downward diagonals on the scale record decreasing percentages of white, while the black content is constant for each series. Upward diagonals record decreasing percentages of black, while the percentage of white remains constant for each series. Each step in the scale (where diagonals cross) is identified by a two-letter symbol. One letter indicates the black content; the other, the white.

In effect, the qualities we know as value and chroma lose their separate identities and are merged on the single scale. The steps of this scale, however, are rigidly determined by the precise formulas of the percentages, and they are the same for each hue. In this way the standards for the variants of color are fixed, and

the color scales have a mathematical foundation comparable to the measured tonal scales of music.

In producing the scales the percentages of mixture are measured upon calibrated Maxwell disks, spun on a motor, and the resultant color—as seen on the spinning disk—is matched in pigment.

The virtue of a single scale for all variations within a single hue is that it makes possible certain harmonic groupings based upon similarities in formulas—such as colors with equal white content or with equal black content or colors chosen at equal intervals on the scales. Ostwald himself was intrigued with the mathematical potentials for the selection of color harmonies from his scales, and he felt that they would open up new vistas in the art of color.

Indeed, the Ostwald scales serve the purpose of harmonic groupings of colors extremely well, and they have proved of great value to industry, where it might be important to have harmonizing colors throughout a line of products.

In practice the standards must exist for the worker in the form of a catalog of color chips organized for rapid referral. Failing that, the worker must patiently build his own scales or mix the formulas he selects upon the spinning disks and match them with pigment.

The Ostwald system does not recognize the varying potentials in pigment strengths of the different hues. The "pure" hues of the Ostwald circle are equated so that all have reasonably comparable pigment strength, or chromaticity. Since Ostwald's time the scales have been revised to accommodate the generally stronger pigments which are now available. Present scales, therefore, differ somewhat from the original ones.

It should be noted that none of the systems of color standardization, or theories, as they are frequently called, are concerned with the designer's problem: the creation of visual unity. The relationships of the variables of color (hue, lightness-darkness, and dullness-brightness, by whatever names we choose to call them) still require the organizing skill of the designer in presenting them to the observer. Since the Ostwald scales merge the iden-

tities of lightness-darkness and dullness-brightness, the designer must translate the Ostwald harmonic groupings into their essential visual stimuli when he seeks to create a visual unity. The principles of design are not pertinent to the coercion of the measured percentages of the Ostwald scales, but they are basically pertinent to the ordering of the color sensations themselves.

THE ROSS SYSTEM

Denman Ross, a teacher at Harvard University, developed a very workable system of color classification based upon the painter's palette. He utilized the earlier pigment studies, but he elaborated the system with a workable terminology for all variants of color. Less scientific than either the Munsell or the Ostwald system (since the measurements involved are those dependent upon normal visual responses), the Ross system, perhaps for this reason, gains in practicality for the creative worker in color.

Ross's terminology and devices for description are not far different from those of Munsell. His hue circle, however, is composed of the twelve hues of the pigment circle. Complementary hues are the pigment complements. His value scale is precisely the same as Munsell's, except that instead of numerical indications he uses word symbols, Figure 4.

Comparable to Munsell's term *chroma*, Ross uses the term *intensity*, which is perhaps a more readily understood label for this variable of color. The intensity scale is simplified to five practical steps: full intensity, one-quarter neutralization, one-half neutralization, three-quarter neutralization, and neutrality.

In the present study we have utilized many of the features of the Ross system where pigment resources were involved. However, the pigment circle is not entirely valid as an instrument for charting the visual relationships of hue, since pigment complements differ somewhat from visual complements; see Figure 8.

In all other respects the Ross system could be substituted for the Munsell throughout this study. If the student prefers to work with the Ross system, he should switch to the light circle when charting his color schemes.

On the whole it is better to admit the existence of this duality of pigment and light which actually exists in the designer's problem. The designer must know the resources of his pigments and their interactions in mixtures, yet as he combines colors for their visual impact he must be concerned for an equilibrium of hues based upon the visual complements.

THE MUNSELL SYSTEM

Since a detailed description of this system appears in Chapter 3 and elsewhere in this book, it remains only to indicate the reasons for our choice of this system for the present study and the reasons for certain departures from it.

The Munsell system was chosen for the present study because it offers certain advantages from the designer's viewpoint. In Munsell's hue circle the complementary pairing of opposites is true to the optical experience of simultaneous contrast and the after image (Chapter 2), which specifically designate the visual complementary hue sensations. This is extremely pertinent for the creative worker in color, who is necessarily concerned with the visual oppositions of hue.

Munsell's system, like Ross's, provides for separate ranges of value and chroma which give the designer the necessary concepts for ordering each of these elemental qualities of form.

In the present study we have not been overly concerned with the precise numerical standards for chroma, since for practical creative purposes the broader truths are more significant. We have, for example, suggested a simplified scale of chroma (see the constant-hue chart, Chapter 4), which parallels the Ross handling of this element.

We have, moreover, necessarily departed from Munsell's concepts when dealing with pigment manifestations. As explained in Chapter 4, pigment, while reflecting light and providing the light stimuli with which the designer builds his form, is, nevertheless, a physical substance whose behavior follows its own laws, not those of light. It was necessary, therefore, to introduce certain aspects of the pigment-derived system to provide the foundations for the understanding of pigment truths.

Index

135

Index